CORPORATE & LOCATION PHOTOGRAPHY

Gary Gladstone

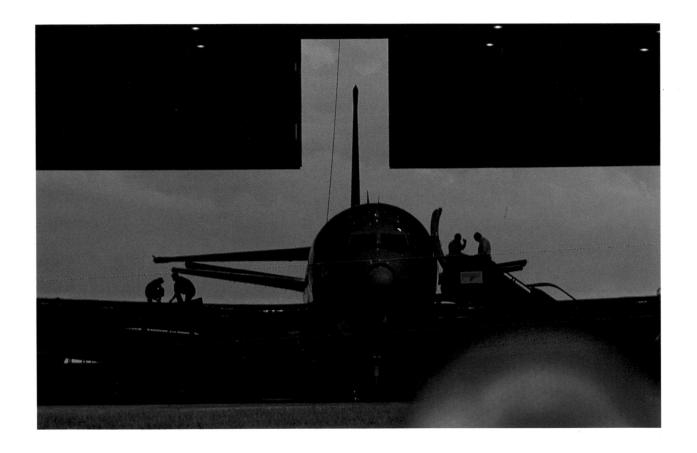

KODAK Pro Workshop Series

Silver Pixel Press®
Rochester, New York

1F 84

KODAK Pro Workshop Series

CORPORATE & LOCATION PHOTOGRAPHY
By Gary Gladstone

Publication PW-3
Cat. No. E147 2651

Kodak
LICENSED PRODUCT

KODAK Books are published under license
from Eastman Kodak Company by
 Silver Pixel Press®
 A Tiffen® Company
 21 Jet View Drive
 Rochester, NY 14624 USA
 Fax: (716) 328-5078

Library of Congress Cataloging-in-Publication Data

Gladstone, Gary.
 Corporate and location photography / Gary Gladstone.
 p. cm. -- (Kodak pro workshop series)
 ISBN 0-87985-784-6
 1. Commercial photography. 2. Photography, Industrial.
 3. Photography--Business methods. I. Title II. Series.
 TR690.G54 1998
 778.9´96591--dc21 98-18364
 CIP

DEDICATION

For my mentor, Walter D. Osborne, Jr., who lovingly shared the secrets of becoming a good professional. A soft-spoken man of immense literary and visual talent, he once offered me a galvanizing piece of advice. It was the only time I ever heard him raise his voice as he bellowed at me across the assignment desk in a newspaper city room, "Don't tell me the problems, just do it, dammit!"

CONTENTS

INTRODUCTION

I'm in my studio three hours before sunrise, getting ready to leave New York City for a December shoot at a remote location in North Dakota. The latest forecast predicts that wind chills at our destination will be between 60 and 90 degrees below zero. ■ My assistant arrives at 5:00 AM. We go over equipment lists until the car service comes at 5:30. Everything is ready. We load the equipment and depart for the airport. ■ Five hours later we're in North Dakota. We claim our luggage and meet up with three bank executives. I am to photograph them on a windswept oil pipeline 90 miles away for my client's annual report. Because of limited daylight, the executives will drive while my assistant and I fly ahead in a helicopter so that we can be set up and ready to shoot by the time they arrive. ■ The helicopter is slowed by headwinds to a ground speed of 30 mph instead of a normal 90. Jack rabbits, frightened by the noisy helicopter, jump out of their snow holes and actually outrun us. ■ At the site, our executive models are waiting for us. We begin to shoot as quickly as we can.

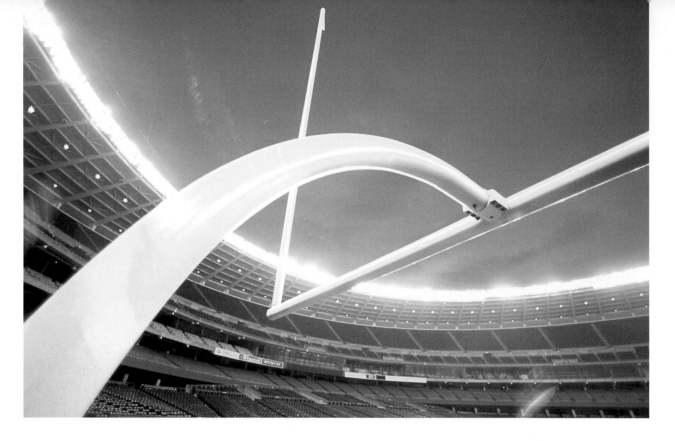

My client wanted images to show that they provided stadium lighting on a grand scale. To make this task more difficult, scheduling forced us to shoot between games when Cincinnati's Riverfront Stadium was completely empty. It was like arriving at the banquet after the meal. After photographing the empty seats for two hours, I took this personal "grab" shot, which ended up being used by the client.

One day you're in a newborn baby ward and the next you're in a munitions factory. Sometimes the locations are so dreary that you have to single out one element to tell the story. The challenge: Make a lovely picture of a killing tool. These tiny bullet jackets are right in your face because the 15mm lens was shoved right into theirs. This shot, taken in the messiest of locations, ended up being the annual report cover.

The camera batteries die after only three or four frames because of the extreme cold. Fresh replacements don't last any longer. Cameras have to be warmed with the car's heater.

After an hour of shooting for one minute and warming up for five, it's clear that both subjects and photo crew cannot stand any more punishment from the severe weather. Utterly exhausted, my assistant and I fly back to the airport to catch our flight home. We are back in the studio in New York by 10:00 PM.

I've just traveled more than 3,000 miles and worked 17 hours to shoot portraits in one of the coldest, bleakest spots on the continent. The next location for this job is in Caracas, Venezuela, where it's summer. I'm scheduled to leave at 6:30 the next morning. Before I turn in, I make a note reminding myself to pack sunscreen. Not an unusual day for a corporate photographer.

The corporate photographer takes pictures for annual reports, corporate capability brochures, and marketing pieces. The photographs are used in these publications to illustrate a story about a company's products

and performance and to sell a specific corporate image to shareholders and customers. The corporate shooter should not be confused with the traditional industrial photographer, who holds a staff position with a company and is responsible for producing photos for in-house uses such as newsletters, presentations, and engineering documentation. The corporate shooter is a freelancer who works in a specialty that sometimes resembles advertising photography and sometimes editorial shooting.

Like the editorial photographer, the corporate shooter goes to a site and shoots whatever is there as creatively as possible. The subject is chosen in advance, but the photographer has considerable freedom to interpret it. In contrast, the advertising photographer must work under the close supervision of an art director and produce images that are precisely determined before shooting begins. Everything is tightly controlled.

Corporate photography comes closest to advertising when producing images of customers using a company's products. The production support for such "real life" images can be comparable to that used for an advertising campaign. Though models are sometimes used in

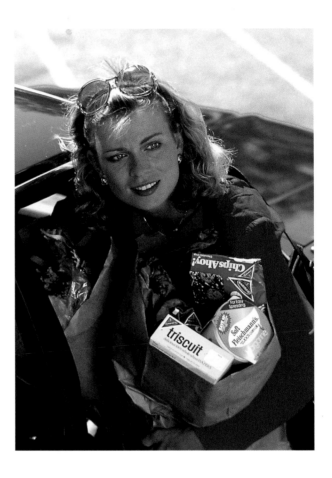

Some clients want to show their products in "real life" situations. This woman was cast to look like a shopping housewife. As much time was spent on precisely positioning neat-looking products in the bag as was spent on grooming the model. A reflector and a borrowed car kept this an economical, "quick-and-dirty" shot. That doesn't mean we didn't work hard, just that it was done quickly, on the fly, without a big production.

Some simple-looking shots take weeks to plan and execute. High production costs make these assignments much more like an advertising shoot. An annual report required one shot of real midwestern Americans in their wheat field. The catch—it had to be their field and the wheat had to be golden. Trouble was, it was after harvest. After two weeks of searching, a professional location scout found the only pretty farm family with a golden field. Being careful not to trample the wheat, we shot from the rear of a pickup that was backed into the scene. The snakes didn't bother the family, but my assistant holding the reflector was pretty jumpy.

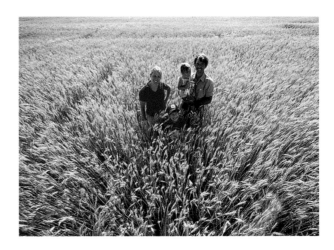

Directing a family of army helicopters by radio as night was falling was a team effort. An army sergeant helped my assistant load camera bodies as we fired off 21 rolls in 12 minutes. The shot was for a wrap-around cover, so we had to direct the drifting aircraft to keep them in the appropriate position. We started with five choppers, but one overheated and another made an emergency landing behind us, leaving only three-fifths of our flying props in place for the shot. Helicopters and camera motors were both pushed to their limits.

these pictures, often actual customers are asked to appear in them. Sometimes the customers are just plain folks; other times the customer is the army.

I began doing corporate photography in the seventies when designers were hiring magazine photographers like me to shoot for annual reports and other corporate communications projects. At the time, the general-interest magazine business was dying. *LIFE, LOOK, Saturday Evening POST, Colliers,* and others were closing their doors. This left many excellent magazine photographers looking for new kinds of work. Preferring the freedom of corporate shooting to the restraints of advertising

A family made up of professional talent was cast to show how telephone lines were not just for talking anymore. The house was rented and the models cast a week before. So many elements were prescribed for the shot (teenager on the phone, home business papers, two phones showing, computer with modem), we stayed pretty close to the script. The models all signed releases for stock photography usages, allowing me to offer the picture for sale after my client used it for the agreed period.

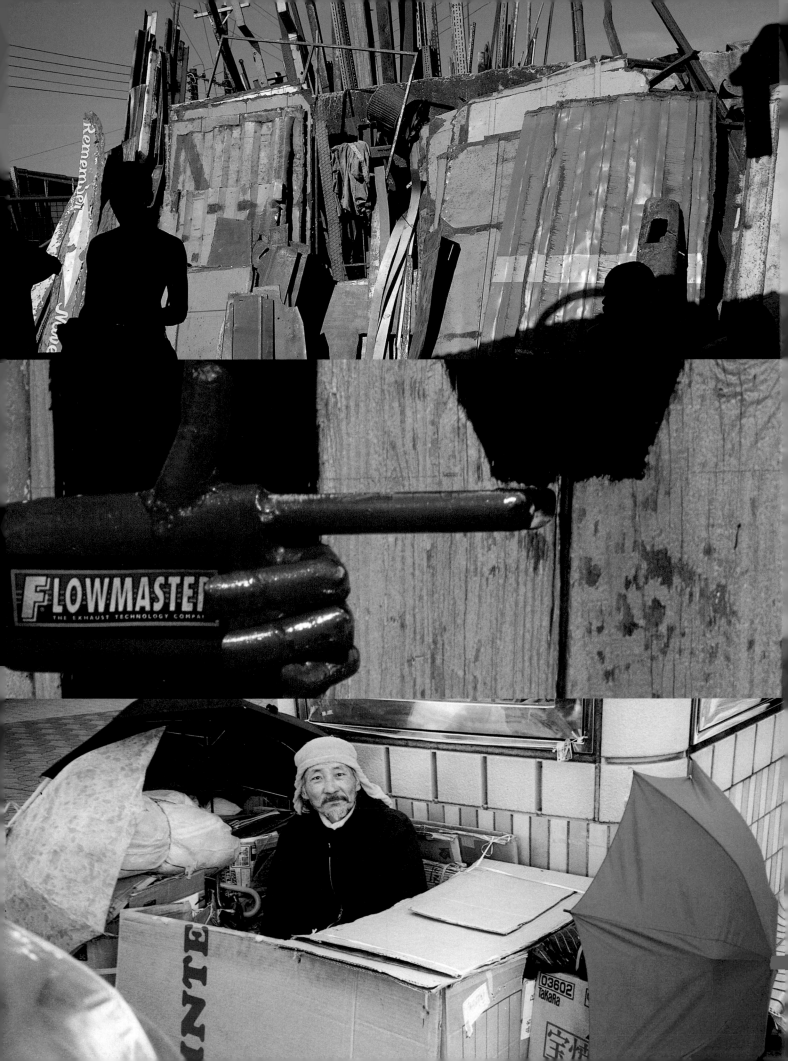

The Cast-Off Recast

Recycling and
the Creative Transformation
of Mass-Produced Objects

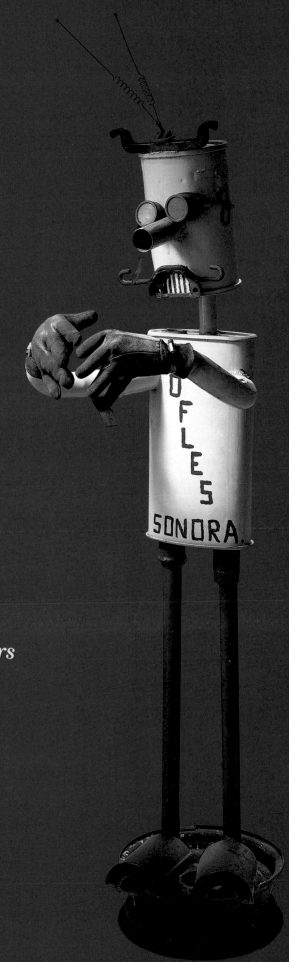

*Timothy Corrigan Correll
and Patrick Arthur Polk, Editors*

With contributions by

*R. Mark Livengood
Maria Cecilia Loschiavo dos Santos*

UCLA Fowler Museum of Cultural History

Los Angeles

Funding for this exhibition
has been provided by

The Ahmanson Foundation
The Times-Mirror Foundation
Manus, the support group of the
 UCLA Fowler Museum of Cultural History

The Fowler Museum is part
of UCLA's School of the Arts and Architecture

UCLA Fowler Museum of Cultural History
Box 951549, Los Angeles, California 90095-1549

Requests for permission to reproduce material from this catalog
should be sent to the UCLA Fowler Museum Publications
Department at the above address.

Printed and bound in Hong Kong
by South Sea International Press, Ltd.

Front cover: Black Dog with White Spots (see fig. 2.25); Soccer
ball (see fig. 3.8); "Pepe" (The World Cup Soccer Player). Muffler,
catalytic converter, exhaust tubing, muffler bracket, nuts, work
gloves, paint, and other miscellaneous items. Height 143.3 cm.
Collection of Gus Lizarde (see fig. 2.73).
Title page: Muffler Man. Mufflers, wheel rim, exhaust tubing,
work gloves, welding goggles, paint, and other miscellaneous
items. Private collection (see fig. 2.20).
Page 143: Space Woman. Standard muffler, resonator muffler,
catalytic converter, front brake rotor, exhaust manifold shield,
exhaust tubing, spring compressor holders, clutch throw bearings,
thermostatic air cleaner hose, paint, and other miscellaneous
items. Height 128 cm. Private collection (see fig. 2.59).
Back cover: Cardboard collector pulling his wagon, Downtown
São Paulo (see fig. 4.41).

Lynne Kostman, *Managing Editor*
Michelle Ghaffari, *Manuscript Editor*
Daniel R. Brauer, *Designer and Production Manager*
Don Cole, *Principal Photographer*

Library of Congress Cataloging-in-Publication Data

The cast-off recast: recycling and the creative transformation of
 mass-produced objects / Timothy Corrigan Correll and
 Patrick Arthur Polk, editors; with contributions by R. Mark
 Livengood, Maria Cecilia Loschiavo dos Santos.
 p. cm.
 Includes bibliographical references.
 ISBN 0-930741-74-9 (hard). — ISBN 0-930741-75-7 (soft)
 1. Material culture Exhibitions. 2. Recycled products
Exhibitions. 3. Mass production Exhibitions. I. Correll,
Timothy Corrigan. II. Polk, Patrick Arthur. III. University
of California, Los Angeles. Fowler Museum of Cultural
History.
GN406.C37 1999
306—dc21 99-27652
 CIP

Contents

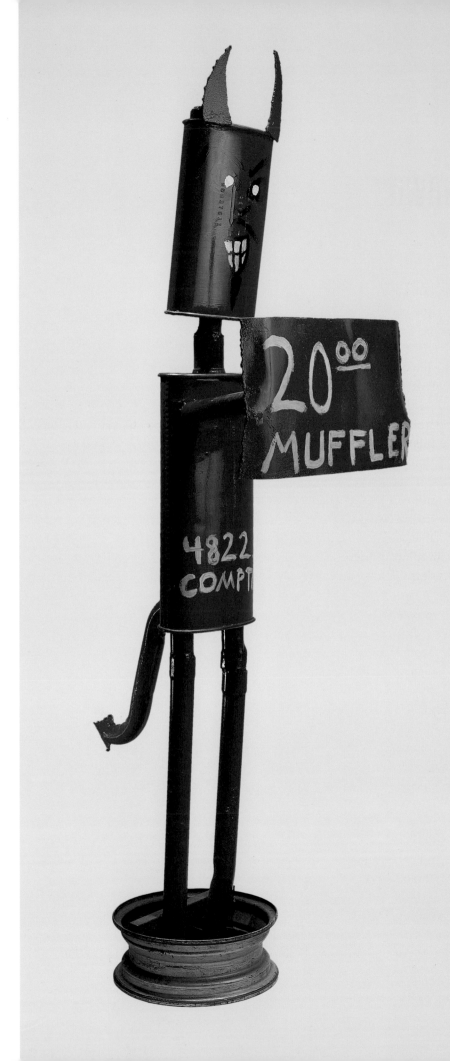

Devil by Jessie Tarula, mid-1990s.
Azteca Tire and Muffler. Mufflers,
metal sheeting, exhaust tubing, wheel
rim, paint, and other miscellaneous
items. Height 197 cm. Private collection.

Foreword

This volume and the three exhibitions that accompany it were stimulated in part by the commitment of the UCLA Fowler Museum of Cultural History to hosting *Recycled, Re-Seen: Folk Art from the Global Scrap Heap*, an exhibition originated by the Museum of International Folk Art, Santa Fe. Another equally important impetus, however, was our desire to highlight the ongoing research of a number of UCLA faculty and graduate students who have addressed the many issues surrounding recyclia from a variety of perspectives.

Recycling is a subject that lends itself to grandiose metaphors, especially during this, the last year of the twentieth century. It is often viewed as a form of salvation at the end of the millennium and as a process essential to the continuance of the next. However, as anyone who has ever returned a used bottle knows, recycling often entails a "cash redemption value." The expended bottle or aluminum can has in fact become a new commodity. The refashioned has become fashionable, and in the galleries of Madison Avenue and Beverly Hills, "outsider" art—often incorporating salvaged debris—is now being aggressively collected by "insiders." The essays featured in this volume and their parallel exhibitions— *Muffler Men, Muñecos, and Other Welded Wonders*; *Streetwise: The Mafundi of Dar es Salaam*; and *Castoff/Outcast: Living on the Street*—critically examine three distinct environments in which a "recycling" process occurs.

From an institutional perspective, I would like to note that this project also has roots in our earlier exhibition *The Sacred Arts of Haitian Vodou* and its accompanying publication. Over the years, the Fowler has taken considerable pride in featuring the dissertation research of UCLA graduate students. Patrick Polk and Tim Correll were the catalysts for the present project and coeditors of this volume. Patrick, a doctoral candidate in the Folklore and Mythology Program, was also an active participant in our Haitian endeavor and the curator of a companion exhibition, *Sequined Spirits: Contemporary Vodou Flags*. I would like to thank Patrick for his ongoing participation in the Museum's programs and for his many efforts on our behalf. His enthusiasm for making university-based research and scholarship accessible to the Fowler Museum's wider audience is unequaled and sincerely appreciated. Tim—also a Folklore and Mythology doctoral candidate—must also be heartily commended for bringing to this study a similarly high level of scholarship and marked commitment to accessibility.

Mark Livengood, yet another doctoral candidate in Folklore and currently the director of the Leelanau Historical Museum, Leland, Michigan, has

assembled a body of material made by the *mafundi* of Dar es Salaam for the Fowler Museum collections. This in turn led to his present essay and its companion exhibition. Mark's work on this project is also greatly appreciated. Finally, I would like to express our gratitude to Cecilia Loschiavo dos Santos, assistant professor in the School of Architecture and Urban Planning at the University of São Paulo, whose photographic essay on homeless shelters, *Castoff/Outcast: Living on the Street*, brings an added and often poignant dimension to this endeavor.

The exhibition *Muffler Men,* Muñecos, *and Other Welded Wonders* has relied on the generosity of several lenders. I would like to thank the following for making works available: Alexandré Mahban and Ken Clarke of the Mirá Paris International Museum; Gary Koppenhaver and Duncan Turrentine of G & R Mufflers; Francisco Solis and Gus Lizarde of Lizarde Auto Service; Joe Loria of Carson Muffler; Miguel Gutierrez of AAA Mufflers and Radiators; George and Robert Luna of The Bomb Shop; and Cynthia and David Comsky

As is obvious from the foregoing, the UCLA Folklore and Mythology Program, soon to be part of the UCLA Department of World Arts and Cultures, deserves special recognition. Spearheaded by Donald Cosentino and Michael Owen Jones, the Folklore Program has fostered a remarkable group of students who have worked in the Fowler in a variety of capacities to ensure an active intellectual life for the Museum's publications, exhibitions, and public programs.

I would also like to join Patrick Polk and Timothy Correll in thanking the Museum staff for their hard and enlightened work on this project. Without them there would be no Fowler Museum.

Doran H. Ross
Director

Acknowledgments

The Blues is a Jes Grew.... Jazz was a Jes Grew which followed the
Jes Grew of Ragtime. Slang is a Jes Grew too.
 —Ishmael Reed, *Mumbo Jumbo*

To borrow an apt metaphor from the African American poet/novelist Ishmael
Reed, this volume represents a collaborative endeavor that "jes grew," emerging
unexpectedly and evolving in an improvisational, and sometimes seemingly
inexplicable, fashion. To be sure, when the authors of the essays presented
here initially set out on their various ethnographic journeys—R. Mark
Livengood to the metal workers' stalls of Dar es Salaam; Maria Cecilia
Loschiavo dos Santos to the homeless squats of Tokyo, São Paulo, and Los
Angeles; and ourselves to the muffler repair shops of Southern California—
none could have envisioned the manner in which their independent, and
ostensibly disparate, research projects would ultimately become intertwined
under the auspices of UCLA's Fowler Museum of Cultural History.
Nonetheless, the strands were somehow woven together.

Convergences of this kind, however, no matter how unanticipated by
some, never happen by mere coincidence. Rather, as is the case here, the joint
representation (and by necessity comparison) of diverse material behaviors
informing the "lived experiences" of residents of several cities across the globe
has been guided by the vision and conjoining energy of Doran H. Ross, the
director of the Fowler Museum. He encouraged and nurtured three separate
studies of salvaging and recycling, and helped transform them into a set of
juxtaposed exhibitions tied together with a unifying book. Under Doran's
sponsorship the collaborative endeavor "jes grew."

When setting out to implement three simultaneous installations and to
publish a volume based on research that spans four continents, there is always
a risk of being overwhelmed by the details, both large and small. This was
certainly a concern, as the Fowler Museum's exhibition schedule was already
quite full by most standards when the germ of this project first began to grow.
Ultimately, the emergent scheme had to be contoured and contained. It was
here, in the careful shaping of the exhibitions and publication that occasionally
threatened to take on lives of their own, that the human resources of the
Fowler Museum—career and casual staff, interns, and volunteers—truly
distinguished themselves. In compiling the text, the patience, ingenuity,
and resourcefulness of Senior Editor Lynne Kostman and freelance editor

Michelle Ghaffari proved that the line between editor and author is often blurred. Where our words failed, their words took over and succeeded. Likewise, the publication clearly bears witness to Director of Publications Danny Brauer's superb eye for design and layout, as well as his exuberant appreciation of recycled art. Furthermore, where critical and difficult choices regarding photographic illustrations had to be made, Danny, Lynne, and Michelle helped to select the most appropriate images to accompany the essays.

The transition from envisioning art in a museum setting to actually getting it there is no mean feat, and the members of the Fowler Museum's Registration, Collections, and Exhibitions departments proved time and time again that almost anything is possible. Kudos go to Registrar Sarah Kennington and Assistant Registrar Farida Sunada, who together with Collections Manager Fran Krystock and her assistants, adroitly tracked and handled the movement (occasionally with little advance notice) of objects in and out of the museum. As always, Exhibition Designer David Mayo came up with innovative ways of interpreting and representing diverse expressive behaviors within the confines of the museum. David, along with Martha Crawford, Don Simmons, and Victor Lozano Jr., brilliantly crafted display contexts that allowed the exhibited materials to speak not only for their makers but also for themselves.

Director of Education Betsy Quick provided invaluable input and support throughout the entire process of planning and installation, continually helping the curators to better conceptualize, synthesize, and present the visual and narrative features of the exhibitions. Thanks also goes to Senior Photographer Don Cole for creating stunning photographic images of exhibition pieces that the collectors could not otherwise have hoped to match in clarity and artistry, and to Director of Conservation Jo Hill who offered ample doses of TLC to damaged or otherwise "distressed" artifacts. Likewise, we are greatly appreciative of the expert assistance of Director of Public Relations Christine Sellin, Accountant Dina Brasso, Accounting Administrator Kathlene Avakian, and the rest of the staff at the Fowler Museum.

Finally, we hope that viewers and readers alike will find the exhibitions and the accompanying volume both enjoyable and enlightening. If our own experiences in collecting some of the materials on display and in helping prepare the publication have taught us anything, it is that artifacts of great ingenuity, singular beauty, and considerable emotional significance sometimes spring forth in the most unexpected places. Indeed, they jes grow.

Timothy Corrigan Correll
Patrick Arthur Polk

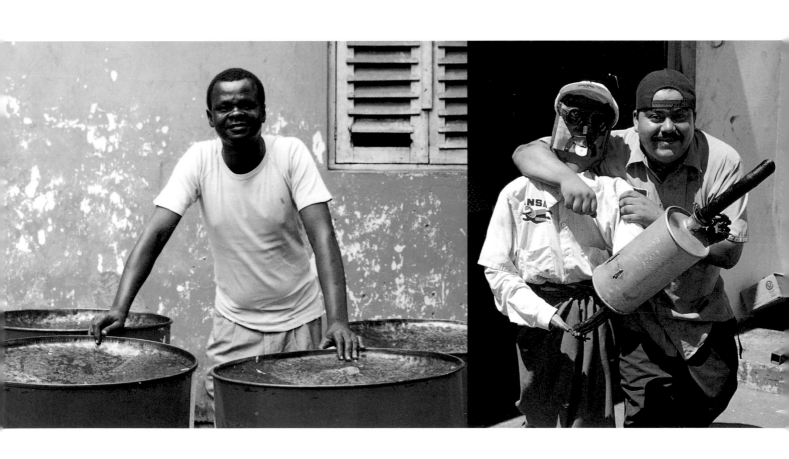

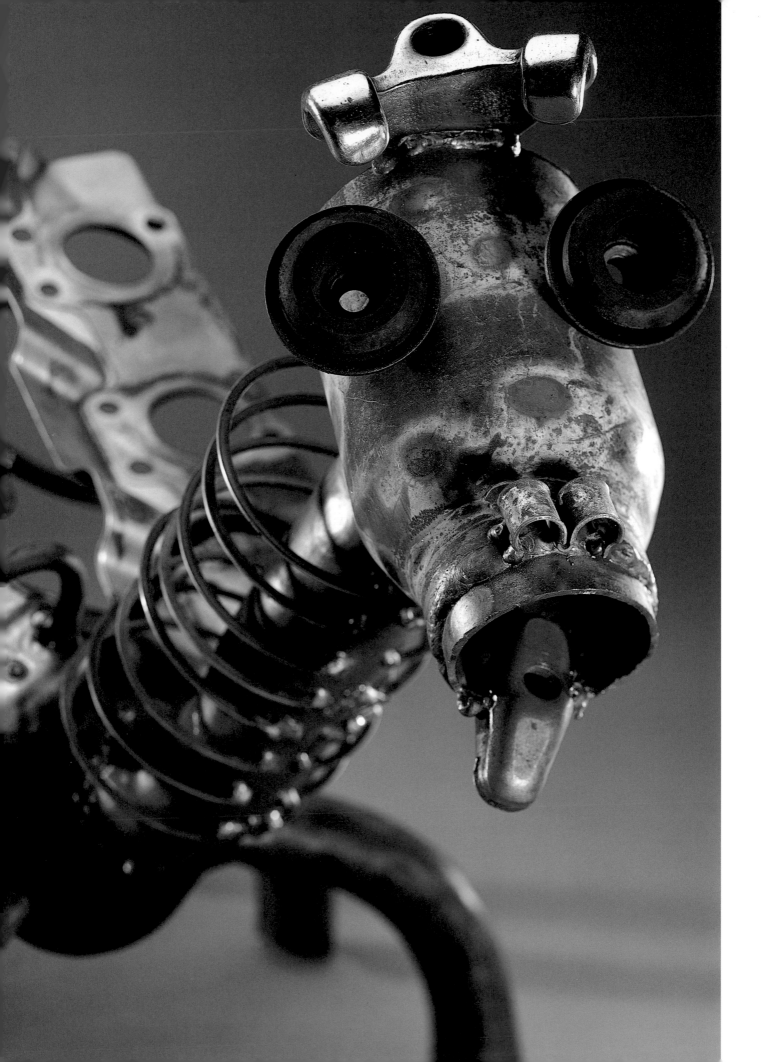

Trash, Treasure, and the Eye of the Beholder

Introduction

Timothy Corrigan Correll and Patrick Arthur Polk

In Los Angeles, as is the case in urban centers throughout the world, the residue of production and consumption—remnants, scraps, rubbish, junk— is filtered through a multilayered recycling system comprised of both formal and informal salvage operations. Each day huge garbage and recycling trucks rumble through the city, their vibrations strong enough to set off an occasional car alarm. At regular intervals, the vehicles screech to a halt as their robotic arms reach out and grab specially marked trash containers. Held firmly by metal pincers, the dumpsters are lifted high into the air and then roughly upended, their contents cascading into immense cargo compartments, mixing with refuse from countless other receptacles. After returning the containers to the ground, the hulking machines roar on to a seemingly endless row of bins.

Like water dripping from trees or rooftops following a rainstorm, less conspicuous curbside salvaging activities are also discernible: the rattle of handcarts maneuvered over the cracked asphalt pavement by street people, trash containers opened by hand and ransacked, the tinkle and clank of bottles and cans as they are tossed into shopping carts borrowed from local supermarkets. Eventually, the hoards of used beverage containers are redeemed at neighborhood recycling centers catering to those who accumulate "alley cash" as a strategy for survival: $1 per pound for aluminum, 5¢ per pound for glass, 50¢ per pound for plastic (fig. 1.2).

Cars, vans, and small trucks also cruise through the streets and alleys of the metropolis. Their drivers carefully scrutinize dumpsters and heaps of oversized junk, searching for salvageable items that will help them to "make do" or "get by." The reclaimed objects are kept for personal use, exchanged for hard currency, or bartered at one of the city's numerous swap meets, flea markets, or semipermanent yard sales. As in any other economic system,

1.1 Detail of *Martian Dog* by Ernesto Ceyvantas, Octavio Franco, and Victor Lopez, 1998. Lincoln Auto Repair and Muffler, Santa Monica. See figure 2.58.

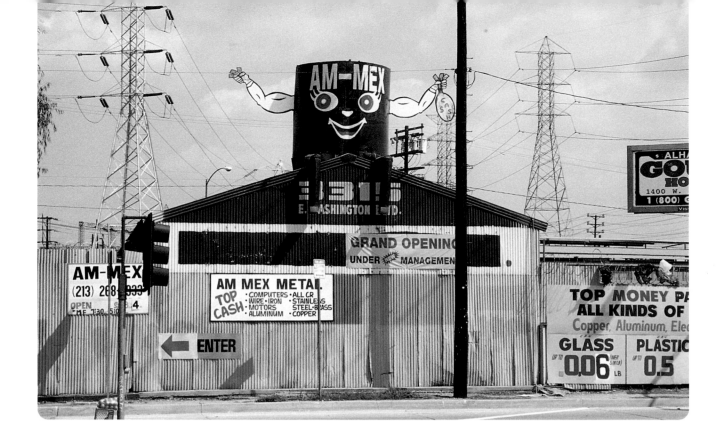

specialized niches have evolved. Some motorists scavenge for used box-spring mattresses and discarded furniture, while others recover cardboard or wooden shipping pallets. Many of the salvagers follow established, and sometimes overlapping, itineraries, traveling only to locations where they know specific goods can be obtained. Muffler repair shops, for example, are regularly visited by at least three classes of gleaners: those who gather used catalytic converters and take them to designated disposal sites for refunds, those who buy damaged mufflers that can be patched and reused, and those who haul away other automotive debris to sell for scrap value.

Still other individuals engage in informal recycling, or "trash picking," on an irregular basis by adopting objects thrown away by their neighbors. Outmoded electrical appliances, damaged furnishings, empty food containers, and other cast-off household items believed to have some residual worth are scooped up and dragged off, often furtively, into the recesses of backyards and storage sheds. Laborers employed in workshops, plants, mills, and other manufacturing professions also participate in similar types of salvaging by gathering industrial materials discarded by employers and coworkers. These remnants—scraps of metal, blocks of wood, cracked ceramic tiles—are then saved for work-related applications or other imaginative uses.

Much of the informal recycling that occurs in Los Angeles on a daily basis takes place largely outside of the public view, nonetheless, the associated behaviors have left their mark on the visual topography of the urban landscape. Commonplace are checkerboard fences, carports, and makeshift living shelters thrown together using reclaimed oddments such as plastic and metal sheeting, cardboard boxes, and scraps of lumber. Although erected primarily out of necessity and with little concern shown for aesthetic impact, the structures have become striking features of the built environment. Other less conspicuous,

1.2 Am-Mex Metal Recycling Center. Photograph by Correll/Polk, Los Angeles, 1999.

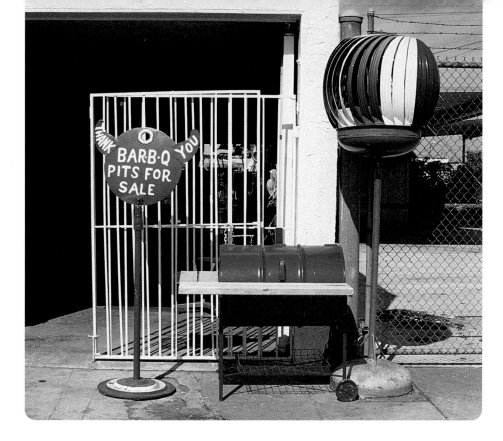

1.3 Smokey's Bar-B-Que Pits. Photograph by Correll/Polk, Los Angeles, 1999.

1.4 Decorated pushcart. Photograph by Correll/Polk, Venice Beach, 1996.

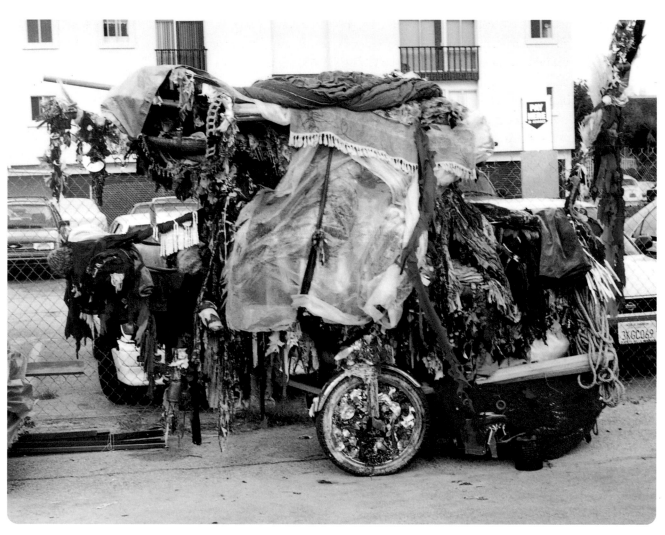

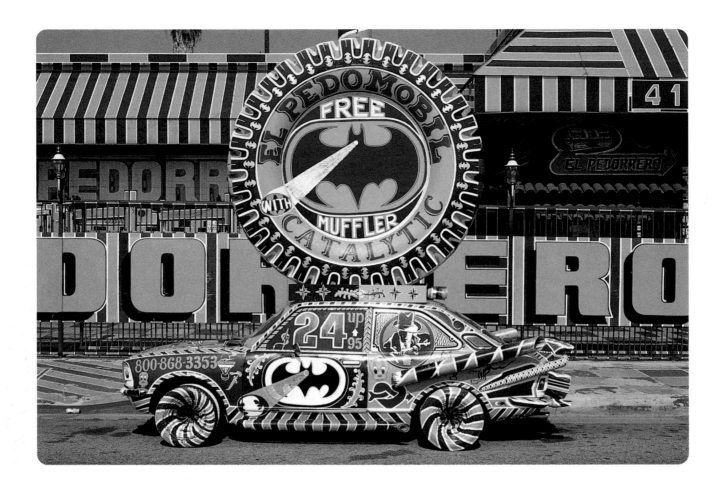

and generally more positively valued, examples of pragmatic reuse include terraced gardens built using railroad ties; trailers fashioned from the detached beds of old pickup trucks; and barbecue pits made from fifty-five gallon oil drums, broken refrigerators, and, in some cases, even trash dumpsters (fig. 1.3).

Reconfigured fragments of urban debris are also used to construct more ornate assemblages: catchy business signs made from the residue of labor; fantastic decorated pushcarts and automobiles adorned with found objects (figs. 1.4, 1.5); and seasonal or permanent yard displays featuring broken toys and any number of cast-off goods (figs. 1.6, 1.7).[1] Built in public space, they invite comment and prompt interactions between the artists, members of the local community, and other passersby. Serving as outlets for creative energy that often cannot be expressed in any other way, some of these artworks swell to gigantic portions. The spires of Simon Rodia's Watts Towers in Los Angeles and the sparkling glass walls of Tressa Prisbrey's Bottle Village in Simi Valley, California, have, for instance, become internationally renowned examples of vernacular construction (figs. 1.8, 1.9). Other creations, such as Daniel van Meters's Tower of Pallets in Sherman Oaks, California, although immense, enjoy mainly local acclaim (fig. 1.10). At the same time, all manner of decorative, but less obtrusive, recycled artifacts are tucked away in private or semipublic areas.[2] Observed primarily by members of immediate social groups—coworkers, customers, family members, and friends—they often

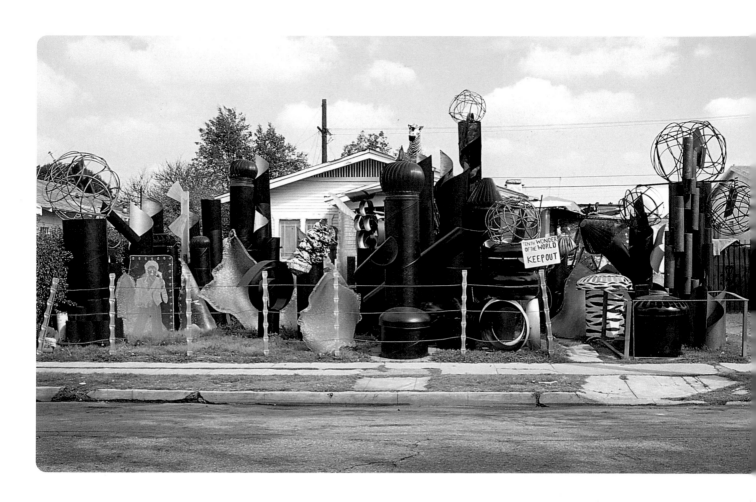

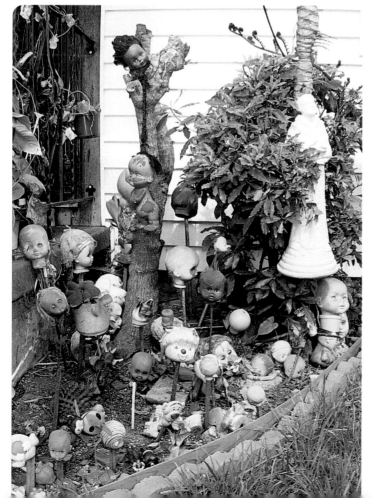

1.6 "10th Wonder of the World" by Lew Harris. Photograph by Correll/Polk, Los Angeles, 1999.

1.7 Doll Garden by Margarita Pichardo. Photograph by Correll/Polk, Los Angeles, 1999.

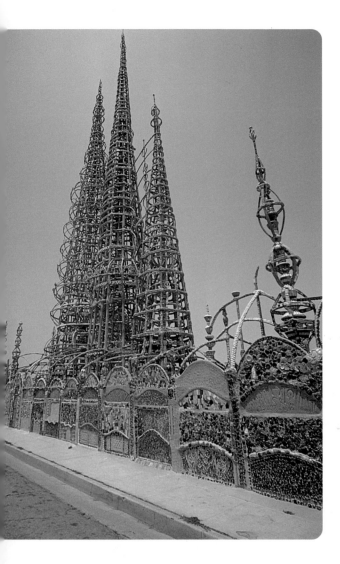

1.8 The Watts Towers by Simon Rodia. Photograph by Bill Pierce, Watts, 1970s.

1.9 "Bottle Village" by Tressa Prisbrey. Photograph by Bill Pierce, Simi Valley, 1970s.

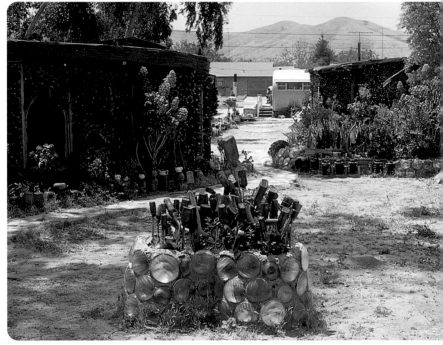

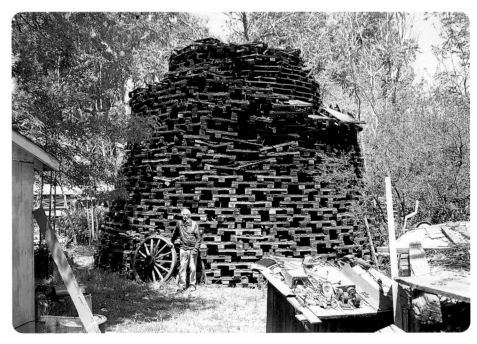

1.10 "Tower of Pallets" by Daniel van Meter. Photograph by Correll/Polk, Sherman Oaks, 1999.

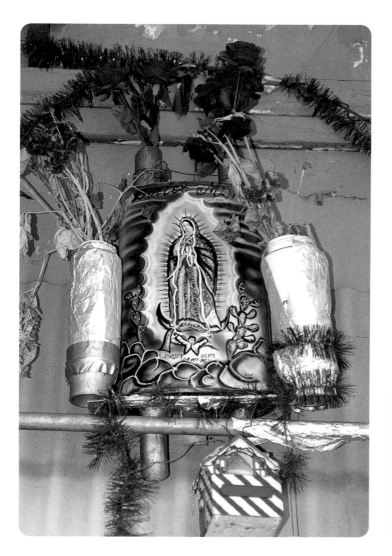

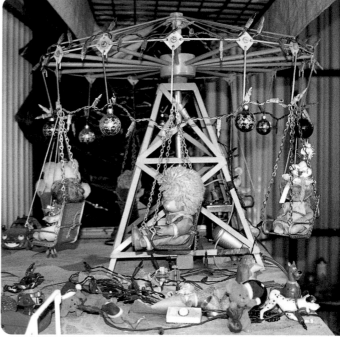

encapsulate intimate relationships and experiences. Notable examples include religious shrines (fig. 1.11), whimsical inventions (fig. 1.12), and playful sculptures (figs. 1.13, 1.14).

1.11 Repair shop shrine. Painted muffler by David Velasquez. Frank's Welding. Photograph by Correll/Polk, Los Angeles, 1999.

1.12 Motorized Merry-Go-Round by Jesus Ortiz. Don Jesus Iron Works. Photograph by Correll/Polk, Los Angeles, 1999.

Recyclia: Genre, Form, and Meaning

The processes of salvage and assemblage that mark built environments so dramatically throughout the world are the subject of this volume. Artifacts created through informal recycling, whether driven by sheer necessity or artistic experimentation, have increasingly captured the attention of academia and the general public. Numerous art exhibitions and scholarly publications evince the ubiquity of "recycled" objects and celebrate the ingenuity of the artisans who craft them. Much as the emergence of American folk art as a genre of collection and display has been tied to the rapid demographic and technological changes that followed the First World War (Metcalf 1986), the growing interest in folk recyclia can be related to heightened concern about the accelerated depletion of natural resources, the population explosion, and the increasingly integrated obsolescence of mass-produced objects.

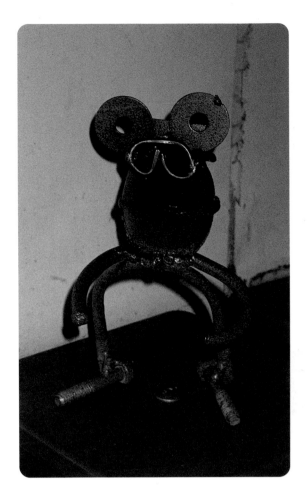

Recyclia bear the "fragments of other sign systems" (Babcock 1992, 209) that have been reconfigured and, therefore, seemingly co-opted or inverted. For this reason, many view the creations as evidence of a material, if not moral, triumph over the cultural hegemony exerted by the industrial societies that spew mass-produced objects into world markets. Accordingly, recycled artifacts have been praised as material representations of indigenous adaptation and resistance to globalization and its homogenizing effects. The heartfelt and often romanticized portrayals of artistic recycling that have helped to establish recyclia as a widely recognized genre of art also, unfortunately, encourage the collapse of the critical aesthetic and functional distinctions that often separate the points of view of those who create the artifacts and those who collect them. Art historian Corrine Kratz questions the tendency exhibited by many art critics and aficionados to "assimilate recyclia's producers to the perspective of their collectors" (1995, 11). She points out that the artificers themselves do not necessarily view their creations as ennobling or liberating, let alone as ironic commentaries on the nature of world systems. Moving to counteract the all too recurrent presentation of refabricated items "as isolated objects, removed from use and placed on display," Kratz challenges scholars and curators alike to address the "multiple aesthetics, constituencies, and contexts through which such objects are engaged" (1995, 7, 11).

1.13 Welded Creature by Wiley Harris. Pasadena Discount Mufflers & Automotive Services. Photograph by Correll/Polk, Pasadena, 1998.

1.14 Welder Ashtray by Miguel Gutierrez. AAA Mufflers and Radiators. Photograph by Correll/Polk, Los Angeles, 1999.

In order to realize a holistic understanding of recyclia, as called for by Kratz, it is perhaps most useful to begin with the analytical approach described by Michael Owen Jones as the study of "material behavior." According to Jones, this mode of inquiry embraces

> not only objects that people construct but also the processes by which the artificers conceptualize them, fashion them, and use them or make them available for others to utilize. It consists of the motivations for creating things (sensory, practical, ideational, therapeutic; see Jones 1995), sensations and bodily movements involved in their fabrication, and reactions to the objects and their manufacture. Material behavior encompasses matters of personality, psychological states and processes, and social interaction in relationship to objects (Jones 1993, 1994, 1996). It also comprises ideas that people associate with objects, the meanings they attribute to them, and the ways in which they use them symbolically and instrumentally (see Musello 1992). [Jones 1997, 202–3]

Thus, by exploring the totality of motivations, meanings, and values inscribed in artifacts during creation and through subsequent use, the intangible facets of tangible things can be better perceived and comprehended.

The fundamental value of a behavioral approach to the analysis of recyclia quickly leads one away from simplistic characterizations of the functional, on the one hand, and overwrought representations of the intentional, on the other. Consider, for example, the informal recycling of print media—magazines, catalogs, newspapers, and so on—that occurs throughout the world. Among other things, these materials are used to wrap food, as toilet paper and kindling, and to decorate living quarters and workspaces (figs. 1.15, 1.16).[3] In some cases, bits or pieces of recycled print have also been incorporated into supernatural beliefs and sacred practices (fig. 1.17). Sheets of newspaper placed on walls, for example, have been said to protect homes from nocturnal visits by haunts and witches, because those malign beings are compelled to stop and read all printed material they encounter and are subsequently transfixed (Puckett 1926, 142).

Key bits of cultural information embedded in the recycling of materials such as print media, however, often go unrecognized as many observers fail to address adequately the motivations for and the specific contexts of reuse. Describing the decoration of a Haitian Vodou temple he visited during the 1940s, one American scholar wrote, "On the hangings were some colored advertisements of some old movies, in French, which the natives could not read. Some visitors to Jacmel or Port-au-Prince had procured them because of their clamorous combinations of pigments. Pages from old French magazines, including 'La Vie Parisienne,' with pictures which had no bearing whatever on the ceremonies" (Williams 1949, 80). In keeping with his supposition that the adornments were meaningful only in that their colors enlivened the mise-en-scène, the author further observed that one female acolyte "perhaps unwittingly, bowed in humility before a grotesque caricature of Charlie

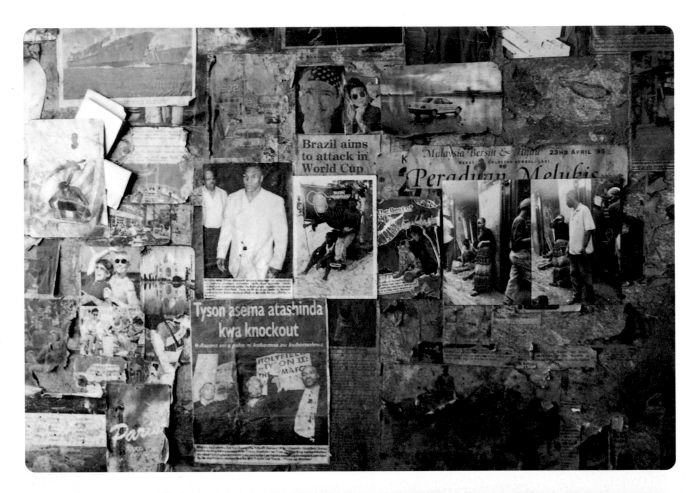

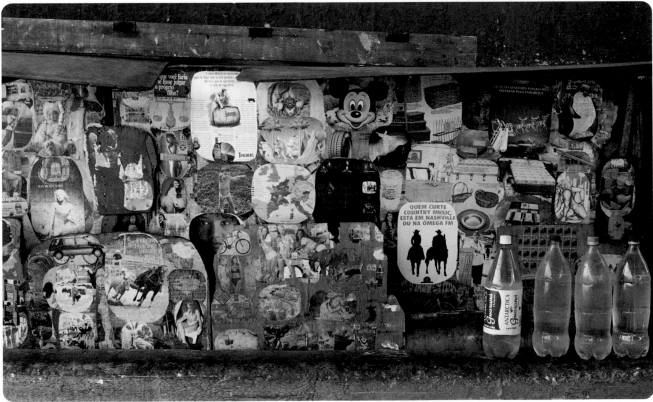

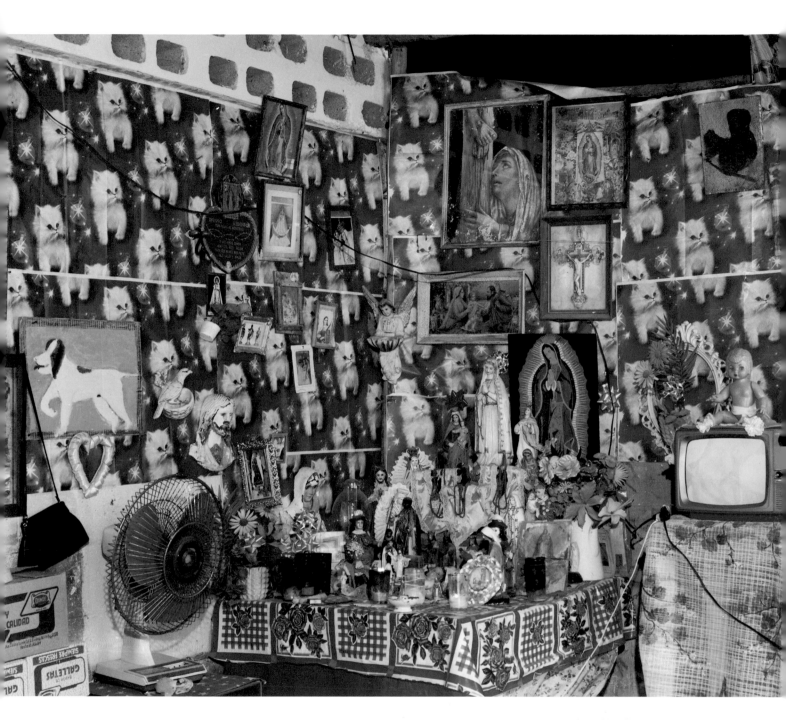

1.17 Home Altar Created for the Easter Holidays by Paula Sanchez. Photograph by Dana Salvo, Quintana Roo, Mexico. This photograph is one in a series spanning the years 1986–1997.

1.15 Mafundi Collage. Photograph by R. Mark Livengood, Dar es Salaam, Tanzania, July 1997.

1.16 Homeless Collage. Photograph by Lucia Mindlin Loeb, São Paulo, Brazil, 1996.

Chaplin which graced a brightly colored advertisement of the almost ancient movie *La Cirque*" (1949, 84).

Because the representational elements of the Haitian temple decor were assumed to be incomprehensible or meaningless to their recyclers, it was suggested that they were, therefore, essentially irrelevant to their lives and actions. Yet as folklorist Simon Bronner has noted, "symbols are not quite singular, uniform, or static. Rather they operate in an open, dynamic system in which certain symbolic expressions can become predominant at a particular moment and place, or in which symbols, often seemingly conflicting, may coexist in the same object" (Bronner 1983, 80). Unfamiliar with the intricacies of the sacred context in which the Charlie Chaplin poster was situated, the foreign observer did not realize that the seemingly out-of-place image of the Little Tramp had, in all likelihood, been brilliantly "recycled" as a depiction of the cane-wielding, bowler hat-wearing, and occasionally clownlike Vodou spirit Bawon Samdi. Irrespective of its original function, the image served to focus both the ritual movements and religious sentiments of Vodou adherents who probably placed the poster in full view of congregants and outsiders quite purposefully. Unless one moves beyond cursory discussions of pragmatic function or desultory comments on the irony of reuse, many of the esoteric meanings embedded in even the most mundane of materials will be missed— half of the story will remain untold.

Charles E. Martin's nuanced analysis of the once-prevalent Appalachian practice of dressing the walls of homes with newspapers and pages torn from magazines stands is a remarkable demonstration of the multidimensionality of such traditions of reuse (fig. 1.18). According to his informants, print media provided insulation from the elements and served as an inexpensive form of wall decoration. Following established decorative patterns, walls were continually recovered with new layers of paper as the old ones became discolored. As a result, a fresh coat of paper not only became a source of pride for homeowners but could also be taken as a sign of good housekeeping by visitors. In some households the papering of walls also served as an educational tool, because the newsprint was often used in games that helped children expand their vocabulary and develop their spelling skills. Others, however, always made sure that the newspaper was hung upside down, "since it was regarded as a sin by some to read anything but the Bible" (1983, 18).

Printed images also enabled individuals to "visually reinforce spatial function" with cartoons affixed where small children could easily see and enjoy them, pictures depicting food hung in dining areas, and recipes pasted near stoves. Likewise, images of male-gender toys were located near boys' beds, whereas pictures of dresses were placed in girls' sleeping areas. Furthermore, images torn from mail-order catalogs or "wishbooks" allowed people to experience, if only in fantasy, the "promises of consumer-oriented and industrial society." Preferred motifs included holiday scenes, houses, automobiles, and elaborate meals. One woman, for instance, decorated her walls with images of cars "because they represented the means to get to all the places, particularly the cities she wanted to see" (Martin 1983, 19–20, 22).

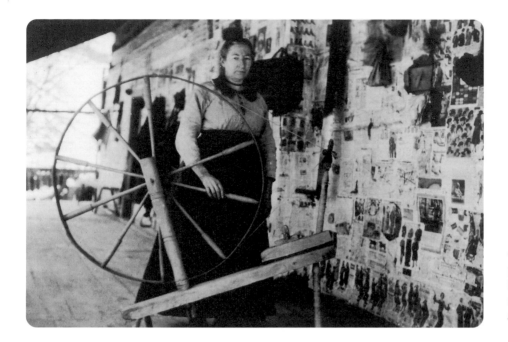

1.18 Appalachian Woman on Her Papered Porch. Knott County, Kentucky, ca. 1925. Photograph courtesy of Alice Lloyd Photographic Archives.

Another favored urban scenes because, she reports, "I've never been to a large city in my life, and I'm a little bit like Tom Sawyer. I guess I like to explore. I explore with my mind even if I've never been there" (1983, 25).

Martin culled rich personal, cultural, and historical insights from a material behavior that few observers have ever found particularly meaningful other than to support notions of economic inequality and crass stereotypes. He notes:

> Although these papered walls are often considered, by the outsider, to symbolize neglect and disorder of Appalachian life, the application and placement of media papers was highly structured, following collectively established patterns but still allowing for the possibility of individual expression. Most important, this practice was based on the Appalachian custom of transforming nonfunctioning machine-made objects into objects fit for everyday use. Worn out shoes, for example, became hinges, and empty lard buckets were turned into stools, or cut into strips and used for chimney flashing. [1983, 16]

Through careful analysis of the aesthetics and motivations that inspired people to cover their walls with recycled paper, Martin discovered that the practice was not only decorative in nature but also served vital social functions and enabled individuals to express their ideals, hopes, and dreams.

Despite the varied ways print media were used in Appalachia, the practice is now moribund. Although some of Martin's informants expressed a desire to continue the tradition, they refrained for fear of being stigmatized as old-fashioned and backward, or to avoid embarrassing "their children or grand-children" (1983, 26). Likewise, while some may delight in the off-center aesthetics of vernacular assemblages such as Lew Harris's yard display (see

fig. 1.6), one neighbor characterized it as a "disgrace" and felt such "junk" should not be placed in public view (Robinson 1987, 25). Furthermore, Rodia's Watts Towers (see fig. 1.8) and Prisbrey's Bottle Village (see fig. 1.9) have also provoked mixed reactions. Some have declared the sites national treasures, while others have described them as colossal wastes of time and money. Differences of opinion such as these remind us that the aesthetic value of such recycling is open to interpretation and that it is necessary to consider carefully the role of what Kratz refers to as "multiple aesthetic constituencies" within the ongoing discourse concerning the artistic, cultural, and personal impact of informal salvage and assemblage.[4]

Muffler Men, *Mafundi*, and Makeshift Homes:
Three Case Studies in Recyclia

Each of the studies in this volume explores how mass-produced materials are reenvisioned and reused in ways that are in dramatic variance with their original intended purposes. Respectively, the authors address the assembly of alluring, eye-catching, and often humorous advertisements made by automotive repair-men in Southern California; the fashioning of implements by craftsmen (*mafundi*) in Dar es Salaam, Tanzania; and the construction of impromptu shelters by street people living in Los Angeles, Tokyo, and São Paulo.

In our article entitled "Muffler Men, *Muñecos*, and Other Welded Wonders: Occupational Sculpture from Automotive Debris," we provide an introduction to the ubiquitous handcrafted sculptures referred to as "muffler men," or *muñecos*, that are used to advertise muffler repair services.[5] An occupational tradition enacted by individuals united by profession, but working at different locations, these metallic figures have been described variously as examples of American "adhocism"(Cerny 1996, 43) or as embodiments of a Tejano (Texas-Mexican) aesthetic style (Graham 1991, passim; Turner 1996, 61). There has been little in-depth analysis, however, of how the works are rendered meaningful as a result of their situational and social contexts. Having visited over ninety automotive repair shops that feature these objects, we explore the polyvalent meanings associated with their creation and use. After presenting general trends observable at numerous sites throughout the region, our study focuses on four shops and explores how idiosyncratic personalities and esoteric workplace experiences influence the construction, uses, and meanings of these comic figures.

As this study shows, the fabrication of muffler sculptures is often a playful activity that allows for expressing creativity and fosters social interaction among shop employees as well as with customers and the general public. Accruing intimate personal associations over time, the muffler men become "memory objects" that embody shared experiences (Kirschenblatt-Gimblett 1989b, 331). Nonetheless, we discovered that although some shop owners would never consider parting with their mascots, many frequently sell their works to interested customers or passersby. Indeed, at some businesses the sculpting of muffler figures has metamorphosed into a profitable genre of commercial art. The growing economic reward affiliated with the production

of sculptures meant for sale has, in turn, prompted artistic innovation on the part of the makers and helped the tradition to thrive.

R. Mark Livengood's essay, "Streetwise: The *Mafundi* of Dar es Salaam," situates Tanzanian craftsmen in a verbal and pictorial narrative that describes how a multiplicity of recycled objects are created and used. He takes us on a journey that explores contexts, moving from the omnipresent role of refabrication as it permeates the daily life of the city to an explication of how the unique lives of men are born out in the work they do. Guiding us into the Dar es Salaam Small Industry Cooperative Society, Ltd. (DASICO), Livengood describes a place of incredible diversity, a place filled with the distinctive sounds of a variety of tools being used to shape metal debris and all sorts of industrial scrap into an unimaginable range of useful items. In so doing, he reminds us that manufacturing is not a seamless practice but rather a human drama punctuated by multiple interactive and expressive forms: the sharing of food, music, gossip, debate, and stories.

His essay also paints a vivid picture of an environment propelled by economic necessity—if not desperation. DASICO, known as a place where men do "the work of hunger," is often a dangerous and unhealthy locale characterized by insufficient safety measures and disease. Despite these dangers, *mafundi* such as Celestine Simama produce everything from *pans*, or drums used in steel bands, to toys, coffeepots, and grills. Also particularly instructive is Livengood's discussion of local or indigenous terminology. By exploring the subtleties of language use and occupational vocabulary, he provides valuable insight into how the *mafundi* conceptualize themselves as craftsmen and interpret the nature of their work. He also illuminates the aesthetic sensibilities that inform the work of *mafundi* and are realized in the objects they fashion.

Moving from Japan to Brazil and the United States, Maria Cecilia Loschiavo dos Santos's photographic essay documenting impromptu living shelters brings into sharp focus contexts where starkly pragmatic concerns bleed together, blend, and overlap with creative impulses. Juxtaposing images of the exteriors of these vernacular constructions with photographs depicting their interiors, she illustrates how these shelters, so often decried as "eyesores" or "urban blight," are considered sanctuaries by their owners. Accordingly, they are decorated with flowers, dolls, and other keepsakes. Like the insides of the shelters, the outsides of homeless assemblages, including pushcarts, may also project a unique sense of identity through external adornment.

Loschiavo dos Santos documents as well the lives of some of the inhabitants as they make their daily rounds collecting cardboard and other cast-off objects. Here we are presented with a variety activities included in an "adaptive repertoire" of strategies for survival, ranging from the scavenging of cardboard to making decorative items from used materials.[6]

Taken as a whole, the essays exemplify the diverse artifacts—ranging from utilitarian to decorative that have, in recent years, been categorized generically as recyclia and folk or outsider art by some, and as junk, rubbish, or the material manifestations of poverty by others. More importantly, they document particular contexts of vernacular creativity and clearly demonstrate

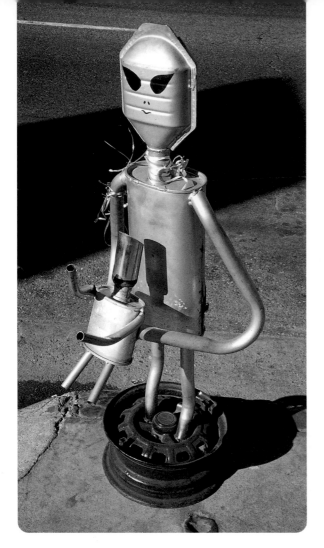

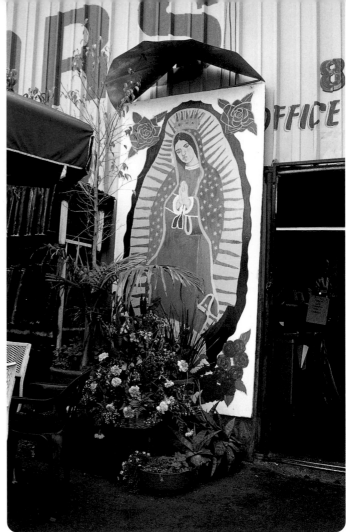

how recycled objects and assemblages are rendered meaningful through the daily experiences of those who make and view them.

Envoi: Things Fall Together

While each of the studies in this volume focuses on specific material behaviors enacted in discrete cultural contexts, it should be kept in mind that these practices are threads of human activity and experience that often fall together within the contemporary urban sprawl. Driving along Alameda Street just south of downtown Los Angeles, for example, one enters into a dynamic cityscape built largely around multiple economies of salvage and reuse. Small foundries, scrap yards, recycling centers, and automotive repair businesses, all operated to some extent by the city's own *mafundi*, line one side of the boulevard. On the other side of the road is a well-used section of train track along which, day in and day out, rail cars creak and groan as they haul both the products and debris of manufacturing. Erected close to the tracks and set against a backdrop of graffiti-scrawled walls and fences are several makeshift shelters fashioned by street people.

Many of the shops on Alameda are decorated with vernacular signage such as brightly colored tires and vibrant murals. On the sidewalk in front AAA Mufflers and Radiators, a huge yellow and red compound, an alienlike *muñeco* decorated with ribbons and balloons has been set out to catch the attention of

1.19 Space *muñeco* with baby by Michael Gutierrez, 1998. AAA Mufflers and Radiators. Photograph by Correll/Polk, Los Angeles, 1999.

1.20 Shrine for Our Lady of Guadalupe. AAA Mufflers and Radiators. Photograph by Correll/Polk, Los Angeles, 1999.

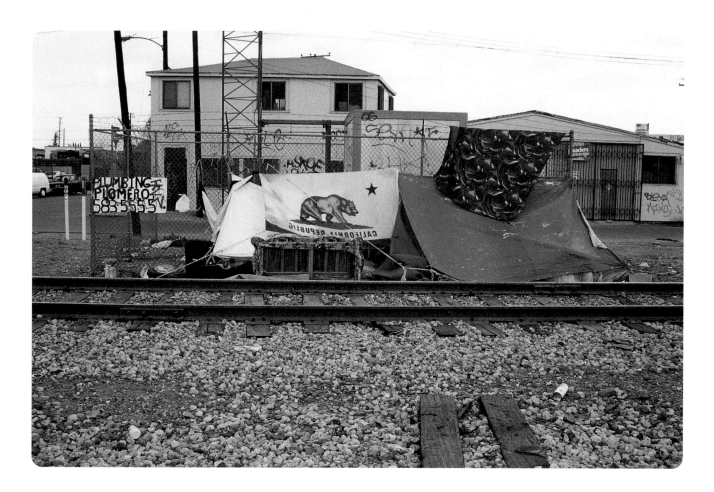

potential customers (fig. 1.19). When one passes through the front gate, in immediate range of vision is a flower bedecked shrine dedicated to Our Lady of Guadalupe, nestled comfortably next to several large racks of refurbished radiators (fig. 1.20). The altar's centerpiece is formed by a large piece of plywood that features a hand-painted image of the holy virgin. Nearby is a table where workers, customers, and other folk who have wandered onto the grounds sit down to eat *fajitas* and strips of *chorizo* that have been cooked on a large mobile grill built by shop employees. Farther back, on a wall at the rear of the shop, is another mural: a radiator with large muscular arms protruding from its sides.

Looking back toward the street, past the employees who are installing retooled automotive parts and beyond the sweating cook who prepares lunch for a crowd of workers and serves up steaming plates of food, and even beyond the "space *muñeco*," one can see several men, across the boulevard and on the other side of the railroad tracks, wheeling shopping carts loaded with salvaged materials. Forcing their carts over dirt and loose gravel, they move along parallel to the thoroughfare slowly heading northward in the direction of several impromptu shelters. Amongst these, one in particular stands out to passersby as it is covered with a large banner featuring the image of a golden bear, the state flag of California (fig. 1.21). ◆

1.21 Homeless Encampment with California State Flag. Photograph by Correll/Polk, Los Angeles, 1999.

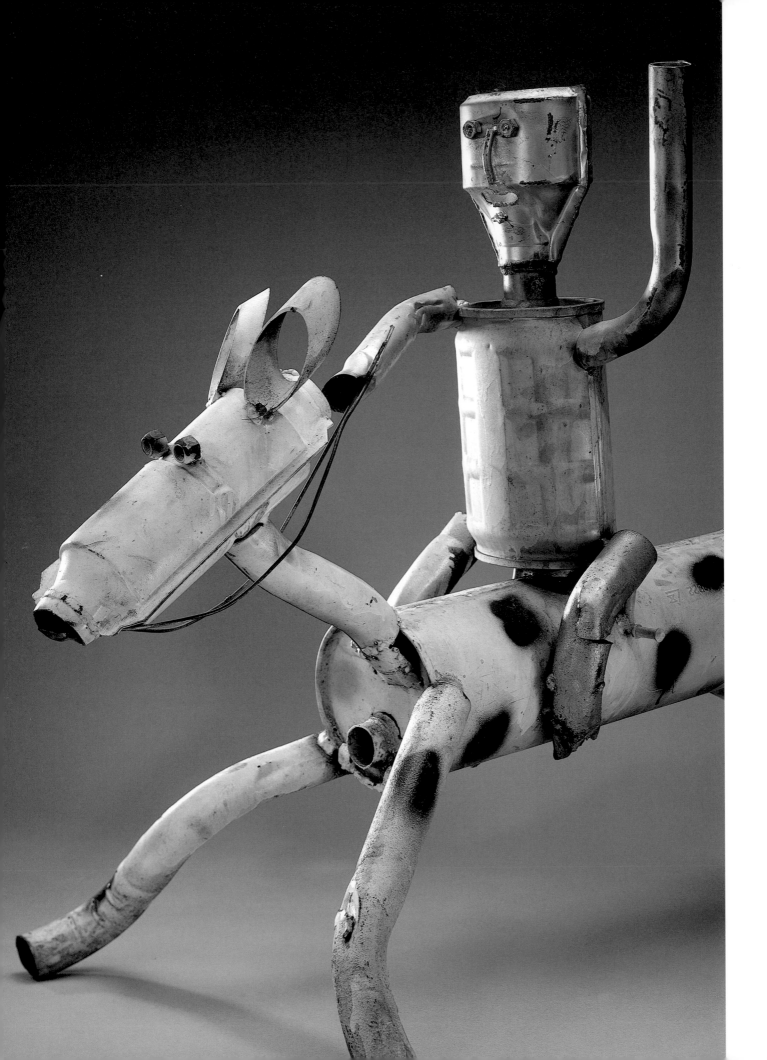

Muffler Men, Muñecos, and Other Welded Wonders

Occupational Sculpture from Automotive Debris

Timothy Corrigan Correll and Patrick Arthur Polk

Workers employed in factories, sawmills, machine shops, and other trades frequently use the by-products of their labor—used parts, pieces of metal, scraps of wood—as raw materials for artistic creation. Such aesthetic endeavors are a common means of breaking up the monotony of the workaday routine through meaningful self-expression.[1] Like their counterparts in other industrial occupations, mechanics who specialize in the installation and repair of automotive exhaust systems often use their professional skills and the resources available to them in the workplace to fashion decorative or symbolic works of art. Particularly remarkable among the artistic creations that can be found at muffler repair shops are the comic anthropomorphic and zoomorphic sculptures workers assemble from damaged mufflers and other automotive detritus (figs. 2.2, 2.3).[2]

In Southern California these sculptures, most commonly referred to by their makers as "muffler men" in English and "*muñecos*" or "*monos*" in Spanish, take on a wondrous array of forms ranging from devils and dogs to pink panthers and prizefighters. Constructed from used automobile parts, reevaluated through an artistic filter, and ultimately recycled as sculptural components, these works exemplify a widespread yet surprisingly unheralded, genre of folk art. Although muffler sculptures are especially commonplace in the burgeoning Latino communities of the Southwestern United States, the production of such art appears to be determined primarily by vocational background rather than cultural or ethnic heritage.[3] In other words, repairmen, Latino and otherwise, craft muffler art because doing so is deemed an appropriate or traditional occupational behavior.

The primary concern of this essay is to document muffler art created by automotive repairmen in Southern California and to illustrate how the tradition

2.1 Cowboy on Horseback by José Reyes, 1998. Lincoln Auto Repair and Muffler, Santa Monica. See figure 2.29

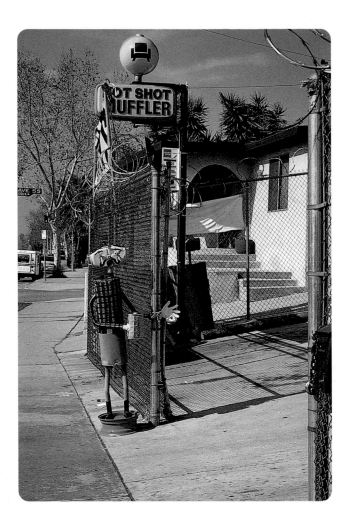 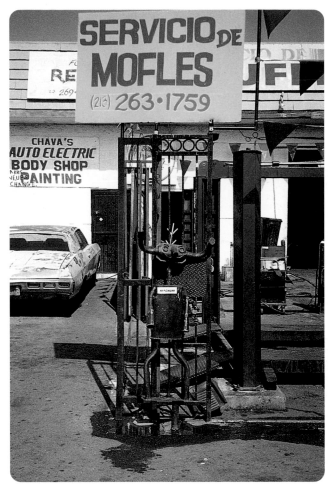

is a "self forming and transforming" artistic process that both reflects and modifies the work experience of the artists (Greenfield 1984, 7). In so doing, we examine the multiplicity of occupational, personal, and cultural meanings that are imbedded in the sculptures as a result of their situated construction and use. As products of either individual or communal experience, we argue that the works encapsulate the "sense of identity and relationship to others, to place, and to the past" of their makers in poignant ways (Jones 1995, 267). Furthermore, as publicly displayed objects that trigger communication between shop workers and passersby, muffler sculptures accrue additional and often unforeseen relevance through the day-to-day events and social interactions that occur in the work environments where they are displayed.

2.2 Muffler Man by Rodolfo Portillo and Sal Martinez, 1985. Hot Shot Muffler. Photograph by Correll/Polk, Los Angeles, 1998.

2.3 "El Toro" by Arturo Medina. San Bernardo Mufflers. Photograph by Correll/Polk, Los Angeles, 1996.

Muffler Men in Context

As the streets and roadsides of America have become increasingly crowded with banners, billboards, and innumerable signs, many onlookers, numbed by the hyperabundance of business signage, have learned simply to stare blankly through or past much of this built landscape. Occasionally, however, the sense-deadening "visual clutter" typically encountered in mercantile districts is dispelled by the emergence of customized storefronts featuring vibrant

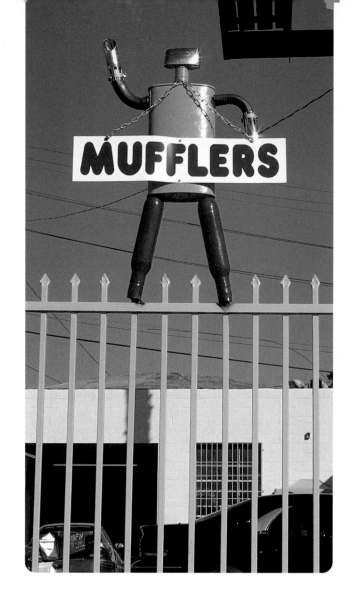

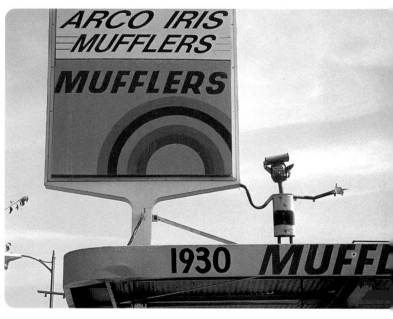

murals, imaginative window art, or handmade signs.[4] Muffler sculptures, much like striped barber poles and wooden cigar store Turks and Indians, represent a distinct form of business iconography that enables the members of a specific profession to advertise their services in signature fashion.[5] Whether the figures are placed on roofs, welded to fences, or dragged out to the sidewalk each morning, they act as metonyms announcing the availability of a particular type of service: muffler repair (figs. 2.4, 2.5).

Like other retail and service-oriented enterprises, many muffler businesses employ a variety of stylized visual advertisements in order to garner customers. Logos depicting industrious or cheerful muffler repairmen commonly adorn signs, business cards, and print advertisements (fig. 2.6). Active and often humorous, these characters derive from the so-called "Funny Little Man" (FLM) graphic image that emerged during the early modern period and became a pervasive feature of twentieth-century American and European commercial art (Smith 1993). Occasionally, the FLM icons used by automotive repair shops actually take the form of anthropomorphized automobile parts (fig. 2.7); thus, funny little men become funny little muffler men. The promotional utility of two-dimensional graphic images is, however, rather limited. For this reason, muffler repairmen also use colorful flags and banners, electric lights, and

2.4 Muffler Man on Shop Fence by Razmik Shervanian, 1998. P & A Auto Sales. Photograph by Correll/Polk, Los Angeles, 1999.

2.5 Muffler Man on Shop Roof, early 1990s. Arco Iris Muffler Shop. Photograph by Correll/Polk, Eagle Rock, California, 1998.

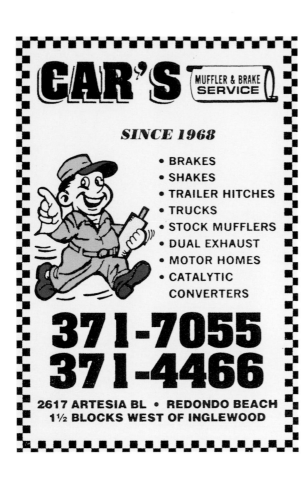

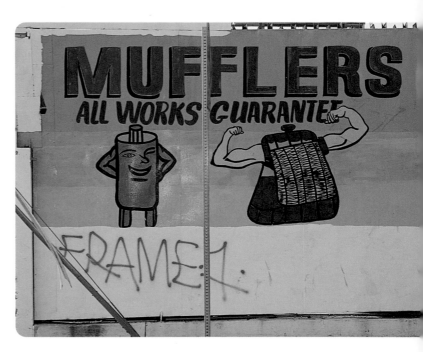

other idiosyncratic forms of signage including, most notably, muffler sculptures (fig. 2.8).[6]

Precedent plays a critical role in the ongoing production of muffler art, as many workers claim that the main reason they make sculptures is because they have seen other repairmen do so. In Southern California the practice of using sculptures to advertise repair businesses dates at least as far back as the late 1950s and may well have originated decades earlier.[7] By the 1960s, the works had emerged as commonplace fixtures at muffler shops throughout the region, and some mechanics believe the art form enjoyed its greatest level of popularity during the 1970s. Most of the sculptures we encountered at over ninety sites, however, were manufactured within the last five years, proof that muffler art remains a vibrant if not expanding tradition.[8] Voicing how prevalent the art form is among members of his profession, repairman Francis Mohsen notes that "just about every muffler shop has its own unique muffler man."[9]

Self-crafted forms of advertisement, muffler sculptures establish lasting impressions in the minds of potential clients, often in ways that no other type of signage can. Repairmen are well aware of this: "The best attraction to the human eye is the [muffler] man," asserts shop owner Joe Loria.[10] At automotive shops that do not specifically mention mufflers on their printed signage, sculpted figures signal the availability of exhaust repair services. Gus Lizarde, owner of Lizarde Auto Service, recalls that when he first hired a muffler

2.6 Telephone Book Advertisement, 1998. Car's Muffler & Brake Service, Redondo Beach, California.

2.7 Muffler Man Mural. Pro-Fit Muffler and Pipes/AAA Muffler and Radiators. Photograph by Correll/Polk, Los Angeles, 1998.

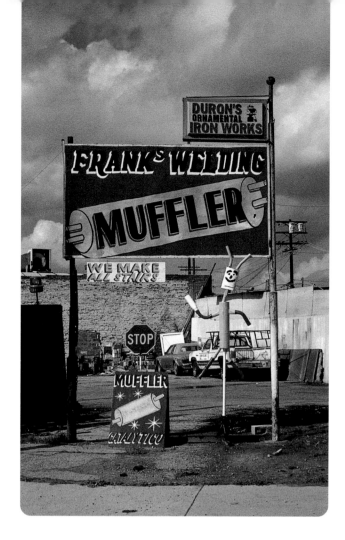

repairman in 1985, the worker immediately made a sculpture "so that people would know that we did muffler work."[11]

Muffler figures are sometimes used to help direct customers to shops that are otherwise difficult to locate. In a large metropolitan area such as Los Angeles, where municipal regulations concerning the size and type of signage that can be mounted in front of a business are quite restrictive, the ability of the sculptures to serve as points of reference is particularly useful. Salvador Martinez of Hot Shot Muffler in Highland Park comments, "People used to tell me, 'I cannot find your place. I go by and I don't see it.' So I got to get a bigger sign than here, but then the city won't let me do it.... They don't let me put nothing up. So then I put one [sculpture] here to hold peoples' attention."[12]

In order to ensure visibility, workers at Huntington Park's A & R Muffler, a small cinder-block garage partially hidden by another building, placed a sculpture directly across the street from their shop. With a painted arrow pointing back toward the workspace, the artwork serves to capture the attention of drivers that might not readily note the signage on the opposite side of the thoroughfare (fig. 2.9). Taking the utility of muffler sculptures as business signage one step further, the proprietors of Mofles Azteca in central Los Angeles have even ensconced a figure with their address marked on it in front of an adjunct business specializing in tire repair that is located several miles away.

In keeping with their primary function as promotional displays, some muffler sculptures have the prices of standard installation and repair procedures

2.8 Horned Muffler Man and Other Signage by Frank Duron Sr. and Frank Duron Jr., 1995. Frank's Welding—Muffler. Photograph by Correll/Polk, Los Angeles, 1999.

2.9 Muffler Adult and Child by Carlos Gonzáles, mid–1990s. A & R Muffler. Photograph by Correll/Polk, Huntington Park, California, 1998.

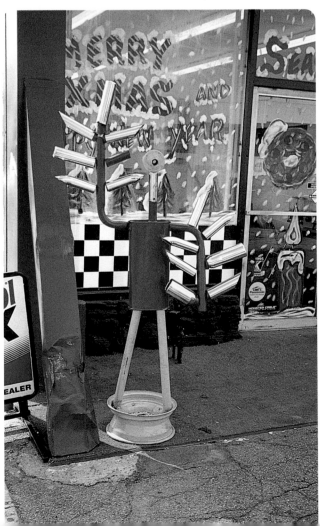
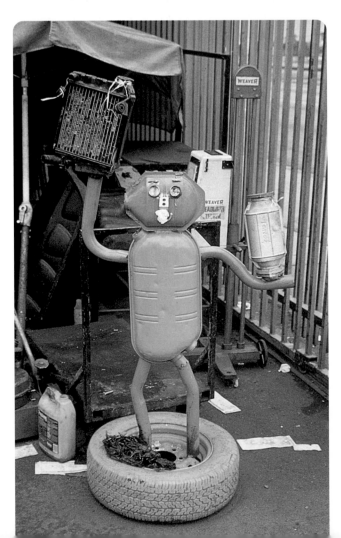

painted on them (fig. 2.10). Sometimes they also bear decals publicizing the availability of certain exhaust system components (fig. 2.11). Specialized parts may be attached to the figures so that customers can look at them and decide if they want to have them installed (fig. 2.12). In addition, the figurines may be used to promote other types of automotive repair available at a shop. A sculpture displayed at AAA Mufflers and Radiators on South Alameda Street in Los Angeles, for example, holds a radiator in its metallic hands—a clear indication that the business also specializes in radiator repair and sales (fig. 2.13).

The constantly shifting economy of automotive repair engenders the frequent movement of workers from one place of employment to another. At times, such moves are marked by the construction of new sculptures by the relocated workers. In this sense, the assembly of a muffler sculpture may serve as a rite of passage in "its use of the natural work context in an expressive, symbolic manner to mark transitions" (McCarl 1978, 157). Asked why he makes muffler art, repairman Francisco Solis reminisces about a giant figure he and his coworkers manufactured when he was an apprentice in Guatemala City, Guatemala.[13] Continuing a tradition he learned at the age of fourteen, Francisco has fashioned such sculptures at each of the various shops where he has worked. Like Francisco, a significant number of repairmen say they construct muffler art because they apprenticed at shops featuring sculptures, and when they moved on to garages that lacked such works or opened their own businesses, they manufactured new figurines for those locations.

Because the sculptures frequently commemorate the founding of a business, many repairmen speak about their first creation and the circumstances of its construction with great pride. Describing the origin of the muffler sculpture displayed at Quality #1 Auto Repair in Los Angeles, Francis Mohsen, the shop's proprietor, relates, "You take it from old pieces. Always, the unique part of the whole thing is just using some of your first mufflers. Yeah, and then your first pipes. You save those first things. You know how you save your first dollar in business, that's how we did it." The recycling of materials in this way, as Barbara Kirshenblatt-Gimblett has pointed out, serves as "a common method of embedding tangible fragments of the past in an object that reviews and recaptures the experience associated with those fragments" (1989b, 331). As objects that signal the beginning of a new phase of one's professional activity and become inscribed with intimate personal meaning over time, the pieces are tangible symbols of both continuity and change.

Despite the utility of muffler sculptures as business signage, their manufacture is generally considered to be a leisure activity, a pastime repairmen engage in during off-hours or when business is slow.[14] Mechanics repeatedly emphasize that crafting sculptures is an enjoyable diversion that involves "messing around" or "getting wild" with used parts, welding equipment, and hydraulic pipe-bending machines. This process, however, should not be viewed as a behavior that is absolutely distinct from labor or one that occurs only during interstitial moments of free time that arise between repair jobs. At shops where the construction of works is an ongoing activity, the construction of muffler sculptures is a creative endeavor that both evolves out of and

2.10 Top Left, Muffler Man with Price of Repairs by Isidro Hernandez, mid–1990s. Azteca Tire and Muffler. Photograph by Correll/Polk, Los Angeles, 1998.

2.11 Top Right, Muffler Figure with Exhaust System Decals by Javier Maldonado and Pepe Ovalle, 1985. AAA Muffler Shop. Photograph by Correll/Polk, Los Angeles, 1998.

2.12 Bottom Left, Muffler Figure Adorned with Chrome Exhaust Tips by Francis Mohsen, 1997. Quality #1 Auto Repair. Photograph by Correll/Polk, Los Angeles, 1998.

2.13 Bottom Right, Muffler Man Holding Catalytic Converter and Radiator by Miguel Gutierrez, 1998. AAA Mufflers and Radiators. Photograph by Correll/Polk, Los Angeles, 1998.

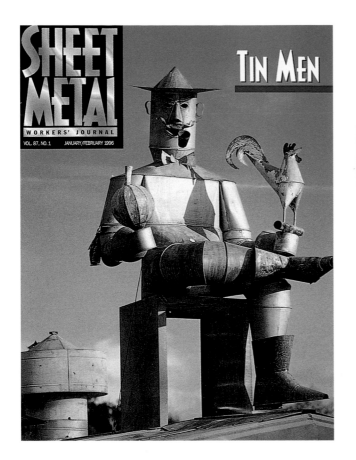

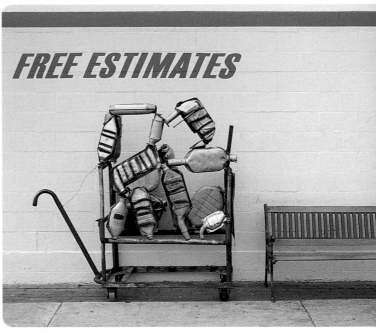

transforms the work routine itself, since the act of removing broken parts from automobiles often suggests designs for works of art. As they are encountered, objects with relatively fixed meaning—broken auto parts—are examined and imaginatively evaluated for possible later use in sculptures. Through this aesthetization of the work experience, the occupational environment is meaningfully enhanced.

As a process that is pleasurable and rewarding in and of itself, the fabrication of muffler art can transform a mechanic's perception of workplace behavior and the constraints of labor. Describing how a repairman can become completely engrossed in the creation of a sculpture, Gary Koppenhaver of G & R Mufflers in Lake Elsinore states, "You don't want to quit when you start making it. You gotta turn customers away, 'Can you come back tomorrow?' [he laughs], 'cause you just want to keep on making it, because you have so many ideas in your head. I guess you could write it down and do it later. But it's inspiration as you're making it."[15] Upending a mercantile paradigm that unquestioningly and unwaveringly ranks financial profit above personal satisfaction as the primary payoff of advanced training, the manufacture of muffler sculptures affords repairmen an opportunity to use their skills for their own pleasure. In a profession where labor is generally considered by clients to be based solely on the application of "practical" or "mechanical" knowledge, and a worker's ability is judged by the amount of time it takes to finish a job, the emotional reward inherent in the creation and public display of artworks can be significant.

2.14 Tin Man by Johnny Jordan. Glenn's Metal Works, a Local 104 SMWIA shop, San Francisco, 1948. Photograph from *Sheet Metal Workers' Journal* 87, 1 (January/February 1996).

2.15 Abstract Muffler Sculpture by Scott Baizer and Miguel Trujillo, 1983. Major Muffler. Photograph by Correll/Polk, West Los Angeles, 1999.

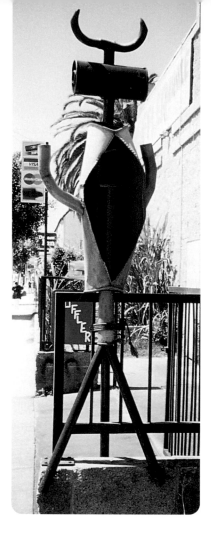

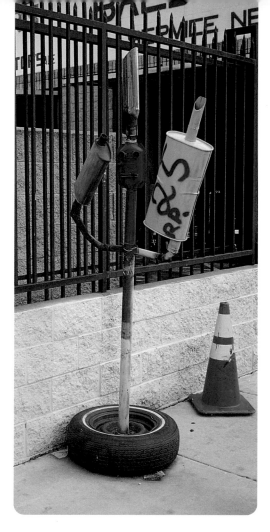

2.16 Horned Muffler Figure, mid-1990s. Custom #2 Muffler & Brakes. Photograph by Correll/Polk, Inglewood, California, 1998.

2.17 Muffler Figure by Jorge Ibarra, mid-1990s. Ibarra's Mufflers. Photograph by Correll/Polk, Los Angeles, 1997.

Why Muffler *Men*? Identity, Self-Image, and Fantasy

As artistic creations constructed by individuals united by profession but working at different sites, muffler sculptures share a close affinity with the "tin men" fashioned by laborers in the sheet metal industry (fig. 2.14). In addition to being used as business signage, these shiny metal statues often serve as emblems for local union chapters, and allow sheet metal workers to demonstrate their skills in a unique manner (Green and Airulla 1996). In much the same way, the construction of muffler men enables professional automotive exhaust system repairmen to craft distinctive emblems. Viewing muffler art as an important "act of identity," many workers assume their sculptures prove to the public that they have the necessary training, tools, and imagination to repair even the most difficult muffler problems. According to Gary Koppenhaver, the muffler man lets the world know, in a way, the level of talent possessed by the workers in the shop. "This is a muffler shop. I want to show people what we can do ... how good of work we can do," says Gary. "If we can do this on a muffler guy, we can probably do pretty good work on a car. And that's what a lot of people say when they come in."

Although a few of the sculptures take on abstract or vaguely figurative forms (figs. 2.15–2.18), the majority of the works are representational in nature. Because they serve as business logos and personal mascots, numerous muffler figures are fashioned in such a way that they appear to be sculptural renderings of shop employees. As if frozen in the act of carrying out daily

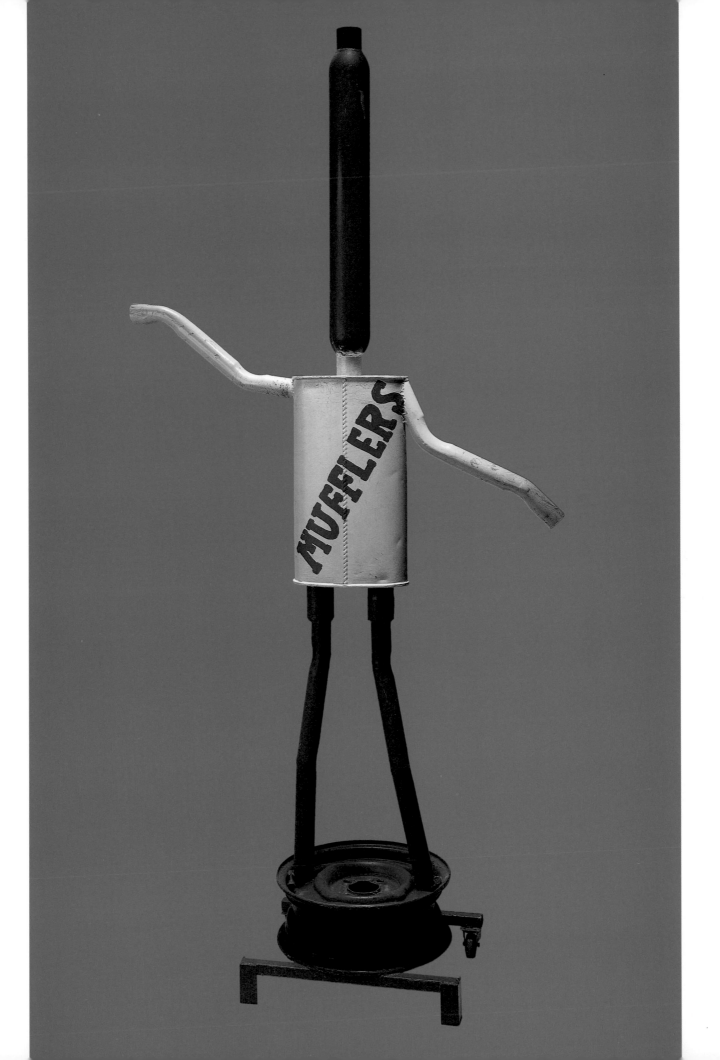

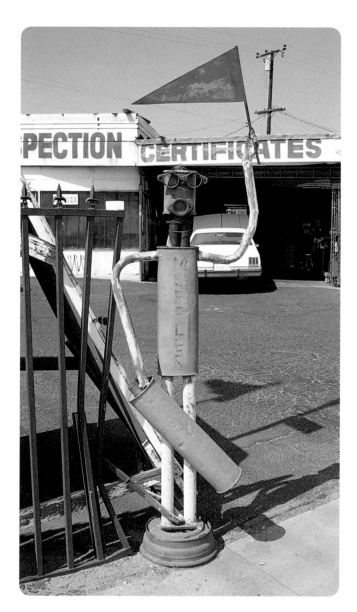

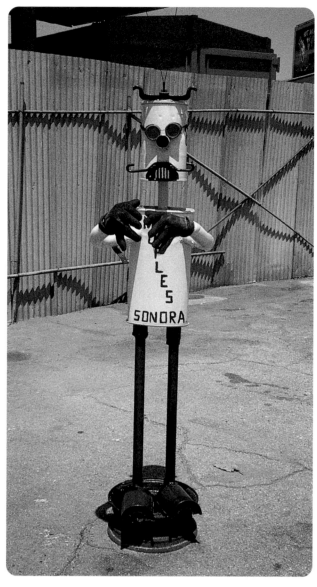

routines, they greet passing traffic with outstretched arms or mufflers in hand (fig. 2.19). The incorporation of objects employed by repairmen while on the job—work shirts, gloves, welding goggles, and the like—adds a touch of comic realism to many of the sculptures (fig. 2.20). "Muñeco" is a fitting cognomen for the statues, since mechanics frequently dress or otherwise adorn their sculptures with cast-off garments and accessories, sometimes changing outfits according to the season or in recognition of special events. Translated as *doll* or *puppet*, the term suggests a plaything fashioned in the shape of a human. Composed of broken mufflers and bits of exhaust pipe, the sculptures are, in a sense, toys for grown men. Like traditional dolls or puppets, muffler characters are imbued with esoteric meanings that derive from both their adornment and usage. Individual predilections and personal experiences, as well as collective ideals, inform the playful and imaginative ways people interact with these material objects.

2.18 Opposite, Figure with Glass Pack Muffler Head by Manuel Rodriguez and Efran Castillo, 1998. Eddie's Mufflers & General Auto Repair. Standard muffler, glass pack muffler, exhaust tubing, tire rim, wheels, paint, and other miscellaneous items. Height 211.1 cm. Private collection.

2.19 Muffler Figure with Red Flag, 1980s. John's Auto. Photograph by Correll/Polk, Gardena, California, 1998.

2.20 Muffler Man by Lupe Ochoa, 1996. Sonora Tire Shop. Photograph by Correll/Polk, Los Angeles, 1998.

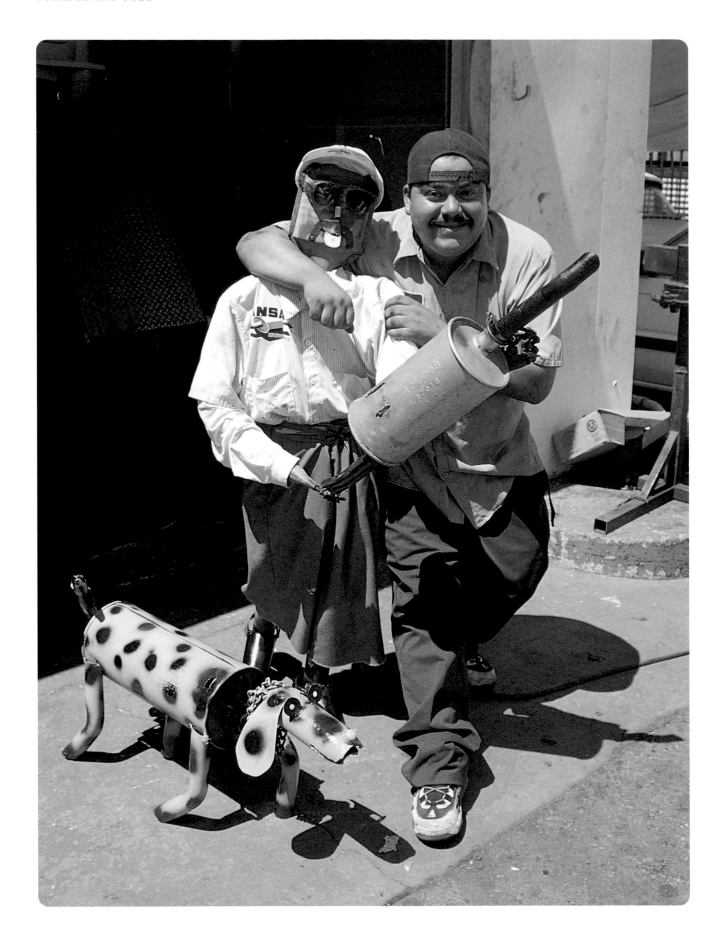

Constant companions in the workplace, repairmen often jokingly describe their sculptures as "coworkers" and, in some ways, treat them accordingly. Asked to assemble for a group portrait, employees at one shop made sure to include their muffler man in the picture. Similarly, the proprietor of another garage has included a series of photographs in his scrapbook documenting the history of his business that show various mechanics posing with the shop's sculpture (fig. 2.32). The collection of images gives one the impression that while workers may come and go over time, the muffler man is firmly rooted to the place. Sometimes the artworks are given proper names, such as Fred or Coco, and may even be described in familial terms. At one location, the owner's wife pointed to a sculpture festooned with a child's bib stationed just inside their repair bay and stated, "He's the baby, so we have to keep him out of the sun" (fig. 2.33).[16] Mechanics at a repair business that specializes in servicing customized automobiles transformed an old and weathered muffler man into a sharply dressed "lowrider" by repainting his face, adding a few additional parts, and clothing him in a pair of knee-length shorts, a work shirt, and a gold chain (fig. 2.21). The workers then playfully referred to the sculpture as their "homey."

Occasionally, repairmen design new muffler sculptures or modify existing ones so that they resemble particular individuals who work at their shop or bring to mind characteristics associated with them. The works may be decorated with cast-off or borrowed items, such as hats, shirts, or sunglasses, and thereafter referred to using the names of the previous owners of the articles of clothing (fig. 2.34). Some of the anthropomorphic muffler sculptures we have encountered were specifically intended to serve as self-portraits of either their makers or the managers of the shops where they are displayed. Once, when he had just completed the construction of a new muffler man, Francisco Solis of Lizarde Auto Service dressed the piece in his old shop uniform complete with a name tag that read "Francisco." Leo Sama, who works at Eddy's Auto Repair in Santa Monica, has a muffler sculpture with his name stenciled on it and a painted face that bears some resemblance to his own visage. Likewise, a muffler man fashioned by Augustin Olivo, proprietor of Auggie's Muffler Shop in Downey, prominently features the name "Capt'n Auggie" written on its belly.

Realizing that muffler figures are likely to attract more attention when rendered in forms that are mutually identifiable and broadly appealing, repairmen also pattern works after widely recognizable icons drawn from popular culture and folklore. The most common motifs include mythological or legendary beings, robots, cartoon characters, cowboys, animals, and figures that highlight ethnic or national affiliation (see pp. 44–47, 73–79). Whether described as "core," "dominant," or "key" symbols, these expressive forms represent fundamental cultural ideas or concepts shared by the artists and many of those who view the sculptures (Ortner 1973; Turner 1967). After all, a basic objective of creating muffler art is, as one sculptor explains it, to make "stuff that people can relate to and enjoy."[17]

2.21 Omar Arevalo and his "Homey." Sculpture by George Luna and Robert Luna, 1998. The Bomb Shop. Photograph by Correll/Polk, Los Angeles, 1998.

Mufflers, Wild and Domestic

The odd shapes and sizes of used exhaust system components have inspired a wide array of muffler beasts. Although some repairmen have created veritable muffler menageries, dogs remain the most popular animal motif.

2.22 Turtle by Salvador Flores and Yasir Flores, 1999. La Tortuga Auto Repair, Los Angeles. Heat shield, exhaust tubing, and paint. Length 34.5 cm. Private collection.

2.23 Duck by Kal Mekkawi, 1998. Affordable Muffler and Auto Repair, Los Angeles. Catalytic converter, valve covers, brake pads, wire hangers, exhaust tubing, tin can, paint, and other miscellaneous items. Height 126.8 cm. Private collection.

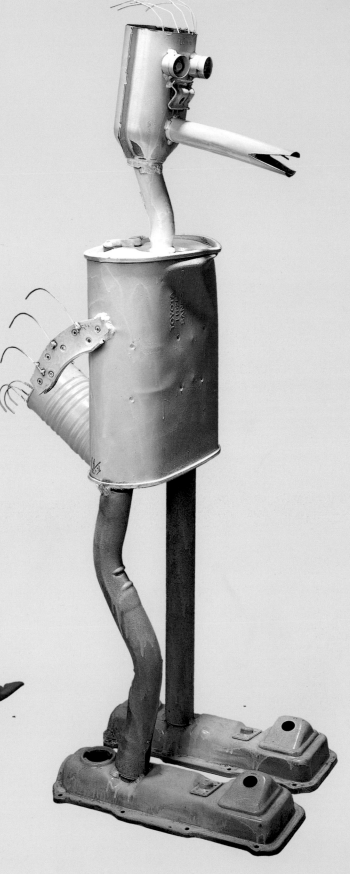

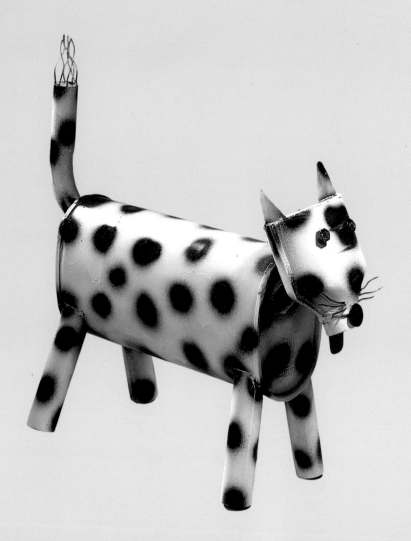

2.24 White Dog with Black Spots by Frank Afra, 1998. Affordable Muffler and Auto Repair, Los Angeles. Muffler, catalytic converter, exhaust tubing, wire hangers, nuts, washer, metal sheeting, paint, and other miscellaneous items. Length 64.1 cm. Collection of Jeri Bernadette Williams.

2.25 Black Dog with White Spots by Yasir Flores, 1998. La Tortuga Auto Repair, Los Angeles. Standard muffler, catalytic converter, exhaust tubing, heat shield, air tube plugs, washers, and paint. Length 65.6 cm. Private collection.

2.26 Wiener Dog by Frank Afra, 1997. Affordable Muffler and Auto Repair, Los Angeles. Muffler, wire hangers, metal tubing, nuts, and other miscellaneous items. Length 73.5 cm. Collection of Cynthia and David Comsky, Beverly Hills.

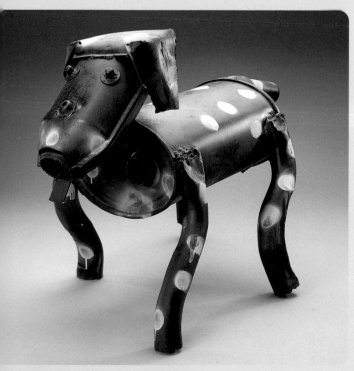

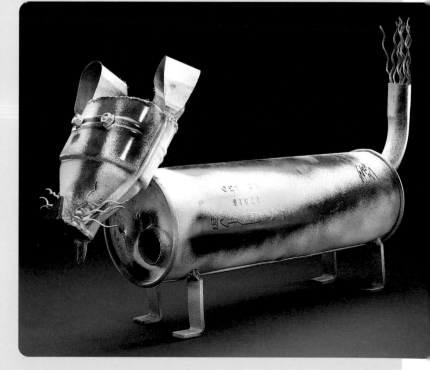

Where the Muffalo Roam...

Cowboys—popular culture embodiments of freedom and adventure—are a recurrent theme among muffler mechanics. Some sport guns and badges, while others smoke cigarettes, play banjos, or ride horses.

2.27 Banjo-Playing Cowboy by Duncan Turrentine, early 1990s. G & R Mufflers, Lake Elsinore, California. Catalytic converters, muffler, exhaust tubing, muffler bracket, metal flashing, springs, trailer hitch spacers, paint, and other miscellaneous items. Height 149.1 cm. Collection of the artist.

2.28 Design for a Cowboy Sculpture by Frank Afra, 1996. Affordable Muffler and Auto Repair, Los Angeles. Collection of the artist.

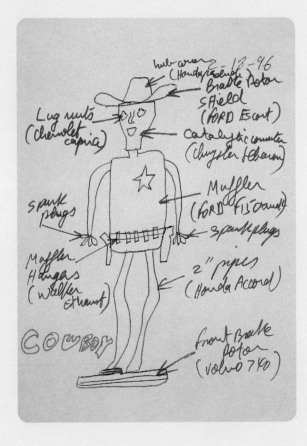

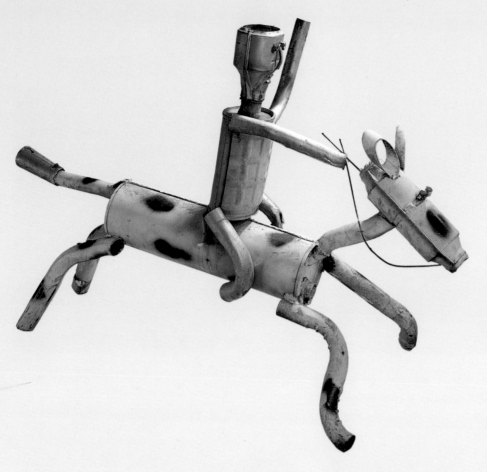

2.29 Cowboy on Horseback by José Reyes, 1998. Lincoln Auto Repair and Muffler, Santa Monica. Muffler, catalytic converters, exhaust tubing, nuts, paint, and other miscellaneous items. Length 128.5 cm. Private collection.

2.30 Cowboy by Salvador Flores and Yasir Flores, 1997. La Tortuga Auto Repair. Collection of Bill Simon and Patty Lombard. Photograph by Correll/Polk, Los Angeles, 1998.

2.31 Cowboy on Horseback by Rodolfo Portillo and Sal Martinez, 1995. Hot Shot Muffler. Photograph by Correll/Polk, Los Angeles, 1998.

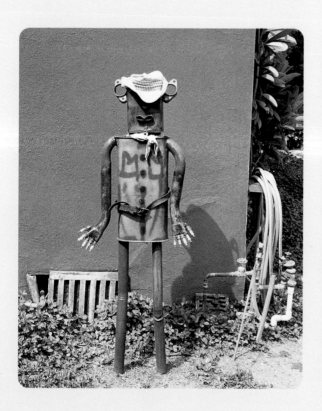

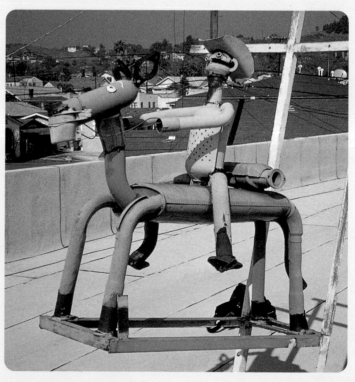

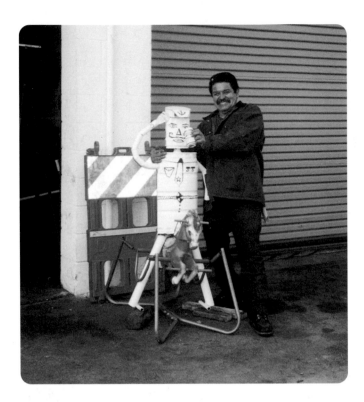 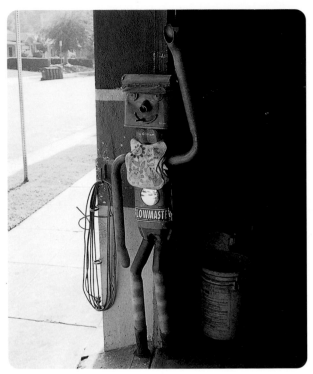

Audience Interaction and Community Feedback

Like other forms of art displayed in public places, such as graffiti, murals, and yard art, muffler sculptures become memorable features of a built landscape that individuals move through in their day-to-day existence.[18] The works capture the attention of viewers and may be used to formulate and express notions of community and locale. Inhabiting routes that people take to work, school, and so forth, they are frequently conceived of as intimate neighborhood fixtures.[19] Some have become so popular as artistic or cultural points of interest that they have been praised in regional newspapers as examples of "local color." The artworks prompt communicative interaction and elicit a wide range of reactions from passersby, including imaginative contemplation and critical evaluations (Greenfield 1984, 11). Although smiles, laughter, and the honking of car horns are the most common responses to muffler sculptures, artists report that adults and children stop at their shops to play or have their photographs taken with the statues, acting like they're boxing with sculptures of prizefighters, putting their arms around statues representing women, and the like. The makers, moreover, receive compliments, queries regarding the provenance of their works, or offers to purchase the pieces. Clients sometimes even try to join in the creation, decoration, and display of muffler sculptures by making practical or aesthetic suggestions. Functioning as conversation pieces, the works often have narratives woven around events that transpire as a result of their presence. These stories find their way into local papers or are related by mechanics to coworkers, clientele, family, and friends.

Muffler sculptures also become targets for pranksters, mischief makers, and vandals. As Sojin Kim argues, vernacular landscapes "reflect not the

2.32 Photograph from scrapbook by Augustin Olivo of Raul Peréz posing with "Capt'n Auggie." Auggie's Muffler Shop. Photograph by Correll/Polk, Downey, California, 1994.

2.33 "The Baby" by Hector Isiordia and Jose Isiordia, 1993. Arco Iris Muffler Shop. Photograph by Correll/Polk, Eagle Rock, California, 1998.

2.34 Muffler Man by Isidro Hernandez, mid-1990s. Azteca Tire and Muffler. Muffler, catalytic converter, exhaust tubing, wheel rim, sheet metal, straw hat, kente-cloth jacket, paint, and other miscellaneous items. Height 161 cm. Private collection.

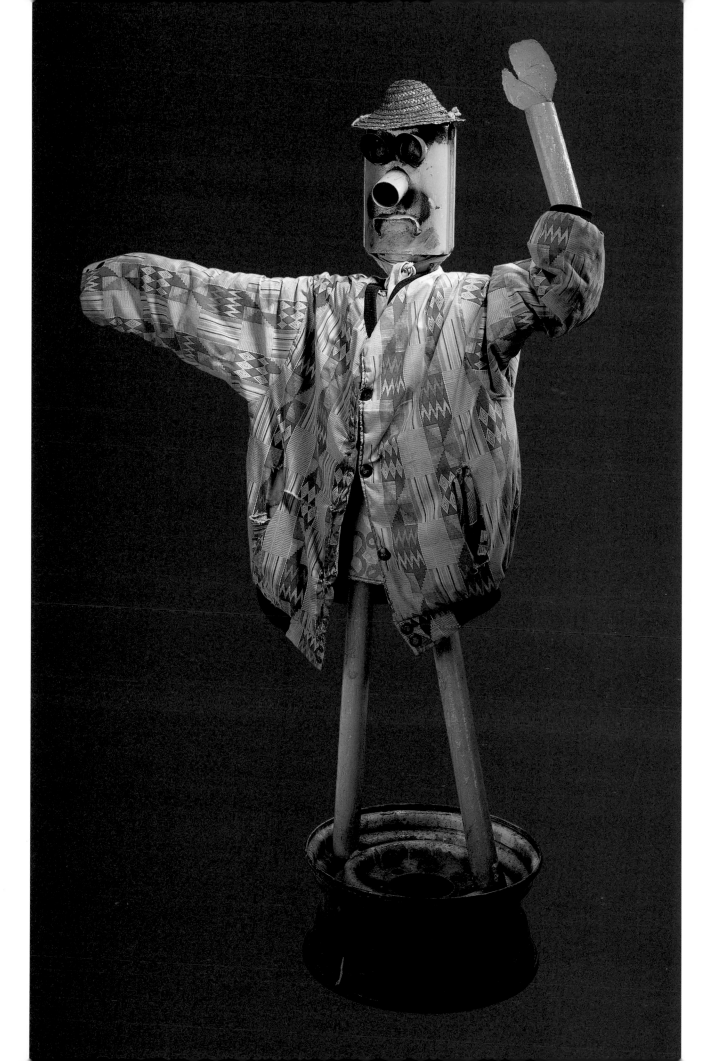

efforts and visions of one community, but the multiple, sometimes discordant, participation of several" (1997, 11). Left unguarded, many works have been decapitated, while others have had their arms or legs broken. Sculptures that remain outside for extended periods may have decorative features such as clothing or other accessories stolen, or they may become targets for graffiti. Positive feedback, however, outweighs the annoyances associated with display, and so, despite the threat of vandalism and theft, the makers of muffler sculptures doggedly persist in their efforts to keep their works in public space. As Francis Mohsen declares, "If they steal it, I'll make another." Similarly, repairman Wayne Wright remarks, "If they tag them up, I'll just spray paint over it."[20] Although damage and environmental wear are generally considered unavoidable, many muffler artists take precautions to insure against the loss of a statue through theft. Works are often chained or welded to fences, gates, or poles so that they cannot be removed without great difficulty.

The social interaction evoked by muffler sculptures—the recognition, affirmative feedback, and resulting gratification—are integral to the continuation of the artistic tradition. Although the first sculpture made by a muffler artist is generally conceived of as a practical, albeit creative, form of advertisement, subsequent community recognition, changing notions of identity, and the possibility of financial gain via the sale of statues frequently leads to the production of additional works.

Exploring Creativity in the Workplace:
A Look at Four Muffler Repair Shops

In order to highlight important aspects of the contexts in which muffler sculptures are crafted and to further illustrate the collective significance of muffler art, we will examine the tradition as it is manifested at several repair shops in Southern California. As an open-ended creative process that inspires ad hoc bricolage, the manufacture of sculptures is more often than not carried out as a group activity with coworkers collaborating on projects and playing off each other's imagination and inspiration. Furthermore, the works are, in a sense, never really completed; they are exposed to weather, vandalism, and creative modification. Thus, the artworks tend to change and evolve over time. They receive fresh coats of paint, gain new appendages when old welded joints come loose or parts break off, and may have new additions contributed by repairmen who were not present when the sculptures were initially constructed. At some shops old figures may be refurbished periodically, while at other locations new pieces are constructed annually or when pre-existing sculptures have been weathered beyond repair, destroyed, or stolen. At shops where muffler figures are frequently made, as many as a dozen works may be on display. At still other locations, the construction of sculptures is a constant process since the objects are perceived as commercial products and are routinely sold to customers who then place them in their galleries, homes, offices, and gardens (fig. 2.35).

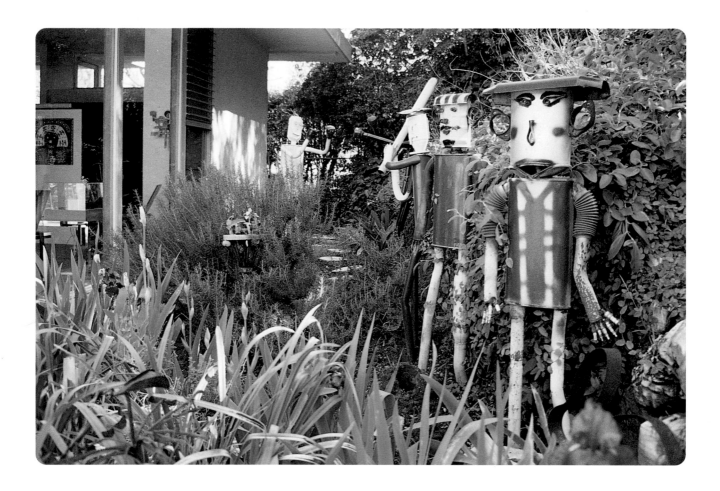

Carson Muffler, 415 East Carson Street, Carson

Without the eye-catching 9-foot-tall muffler robot stationed in front of it, Carson Muffler would, in all likelihood, go unnoticed by many of the people who pass along the busy section of East Carson Street where it is located (fig. 2.36). Carson Muffler typifies independent repair businesses spread throughout Southern California; a small, cinder-block building with just enough space for repairmen to work on several automobiles at any given time. Operated by Joe Loria, the shop first opened in 1958. As a result of his more than forty years of experience operating this shop and others in nearby cities, Loria is well known and respected as one of the "older guys" in the business.

I like the majority of garages that display muffler art, Carson Muffler currently has only one sculpture. Painted silver with red highlights and featuring long stilted legs, jet pipes emerging from its back, and two hornlike protrusions on its head, the giant robot—one of the largest muffler sculptures we encountered—was crafted as an advertising gimmick to grasp the attention of passing traffic. Regarding the ability of the huge sculpture to do just that, Loria says, "You go by, you see all these millions of signs, but if you see this robot you'll remember it…. If I can catch your eye, even if you don't need nothin', that will be a mental note in your head about this, and you'll associate it with the muffler shop." Like other muffler repairmen, Loria and Wayne Wright, who works with Joe, use the sculpture as a point of reference for directing clients

2.35 Muffler Garden, variety of works by employees of Affordable Muffler and Auto Repair and La Tortuga Auto Repair, 1995–1998. Collection of Cynthia and David Comsky. Photograph by Correll/Polk, Beverly Hills, 1998.

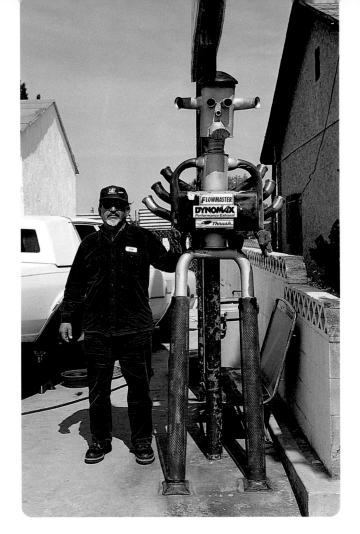

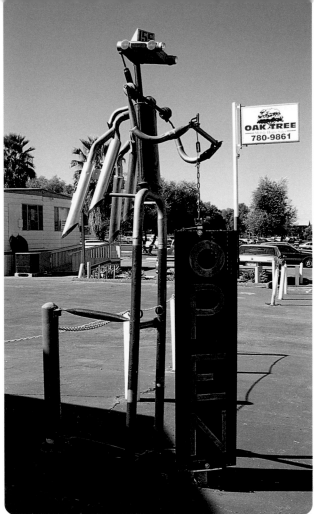

2.36 Joe Loria with one of his many creations, the Carson Muffler Robot, early 1970s. Carson Muffler. Photograph by Correll/Polk, Carson, California, 1998.

2.37 "Johnny-Five" by Joe Loria and Tom Roth, 1992. Riverside Muffler. Photograph by Correll/Polk, Riverside, California, 1998.

to the shop. Discussing the frequent need to do so, Wayne states, "You'd be amazed how many people say, 'Where are you located?' I say, 'Well, between this street and this street.' They're like, 'I don't remember.' I say, 'You'll see the little muffler man.' They say, 'Okay, I know where you're at!'" Thus, the muffler robot not only adds a unique aspect to the shop's visual presentation— one that creates memorable associations on the part of viewers who have already seen it—it also acts as a marker that potential customers can readily locate when traveling to Carson Muffler for the first time.

The idiosyncratic ways other proprietors used surplus military items in the late 1950s to create unique signs greatly influenced Loria's decision to make a sculpture. Unlike most of the mechanics we interviewed, Joe does not recall having seen any other muffler art prior to constructing his own, and says, "I think back then, I don't think there were any. There could have been, but I didn't know it." While it is impossible to determine if Loria's was the first sculpture to be displayed in the Carson area or if it was inspired by other, now forgotten works, the original work is hailed by several other repairmen in the greater Los Angeles area as the piece that "started it all."

The circumstances surrounding the creation of the robot reflect a common expressive impulse shared by many muffler sculptors. Joe recalls that its manufacture was the result of a spur of the moment decision, "We just got a slow day and the guys started looking around in the muffler pile, and we said, 'Well, let's make a robot.' And we just started getting crazy, and we just started

welding things together and throwin' him up…. Just start putting stuff together. Finding old parts and welding them on and everything." Wanting to fashion a unique emblem for the shop and having the free time to do so, Loria and his employees imaginatively reenvisioned the automotive scrap they had stockpiled. According to Joe, the robot theme was inspired by the Cold War zeitgeist of the late 1950s, when American popular culture was rife with images of space exploration and alien invasion. Additionally, and more practically, the mechanical origins and machine-made shapes of the used parts available to the workers were ideal components for a fantasy automaton.

The subsequent evolution of the Carson Muffler robot exemplifies the open-ended approach muffler repairmen take toward the creation and modification of sculptures. Over the years, the original figure has been refurbished and rebuilt. The exhaust system components, for example, that form the cyborg's jet pack were added well after the piece was first created. After having finished a special repair job, workers at the shop noted that the shape and size of the parts they had just removed looked like jet pipes and decided they would make a great addition to the robot. Thus, they welded them to the sculpture.

The robot Loria and his coworkers created at Carson Muffler motivated him to fashion similar sculptures at other muffler repair businesses he has operated over the years. At a shop Joe currently owns in Riverside, he and his employees built an android that is even taller than the one at Carson Muffler (fig. 2.37). Made from a large muffler, shock absorbers, an automobile transaxle, and various other car parts, the work was nominally patterned after the robot character, Johnny-Five, from the film *Short Circuit*. Nonetheless, its current form clearly shows the stylistic influence of the Carson Muffler robot, as it has long legs much like its predecessor rather than the treads Johnny-Five used to move about.

Asked if he would consider selling his original robot, Loria indicated that he might if he received the right offer, since he could simply make another one. Wayne Wright, however, was taken aback when this was suggested and was vehemently opposed to the thought of parting with the work. It had, according to him, been there "too long" and was an important "part of the place." For Wayne, the shop "wouldn't be the same without it." Over time, the sculpture has become what Barbara Kirshenblatt-Gimblett calls a "material companion" (1989b, 330), that is, an item that evokes a sense of attachment as it becomes imbedded with meanings and associations.

Many of the two men's memories of the figure were related to the way it had fostered contact with and been celebrated by outsiders over the years. Wayne, for instance, proudly pointed out that a local newspaper, *The Daily Breeze*, had run an article about the sculpture and even referred to it as a "landmark in Carson." Further describing the communicative interactions stimulated by the piece, Wayne said, "Everybody has to touch it…. I've seen grown men come by here [mimes shaking hands with the figure], 'How's it going, buddy?'"

With a sense of personal satisfaction, Joe told us that every year children from a local grade school, the same one he attended as a child, pass by and

play with the robot on their annual field trip to City Hall. With a wide grin, he then recounted how he had once secretly attached a remote-controlled tape recorder to his robot so that he could make the sculpture "talk" to the children. When they paused in front of the piece, he would activate the recorder and the robot would address them, saying "Hello, kids" or give the following order: "Tell your parents to come to Carson Motors for their car work." This, states Joe, "would just blow their minds."

La Tortuga Auto Repair, 5247 West Jefferson Boulevard, Los Angeles

La Tortuga Auto Repair, a family-owned business run by Salvador Flores and his son Yasir, is located near the rusted and unused tracks of a train line that once carried raw materials from the Port of Los Angeles to the industrial zone near downtown. Salvador brought his family to Los Angeles from El Salvador in 1983 when he was thirty-one years old and Yasir was a small child. When the shop was opened in 1992, Yasir, although still in high school, helped his father with the business as much as possible. In 1993 Yasir began working at the shop full-time following his high school graduation.

Shortly after starting the business, Salvador decided to construct a muffler sculpture for advertising purposes (fig. 2.38). Now standing on the sidewalk in front of the shop chained to a gate post, the sculpture's outstretched hand points toward the entrance to the garage. Although it is only one component of a promotional array consisting of several handmade signs, a large truck tire painted yellow, and a huge black muffler elevated on a pole, the sculpture stands out among the signage. Remarking on the *muñeco* that heralds their business, Yasir points out: "They're for advertising, to get more curiosity from people. You know, they are looking and they stop like, 'Oh, what's this?

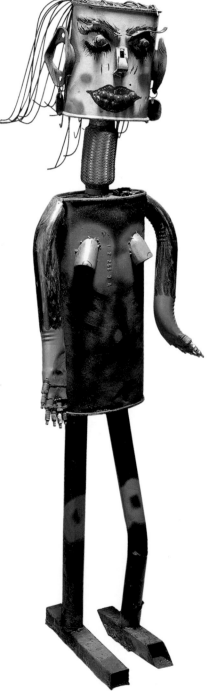

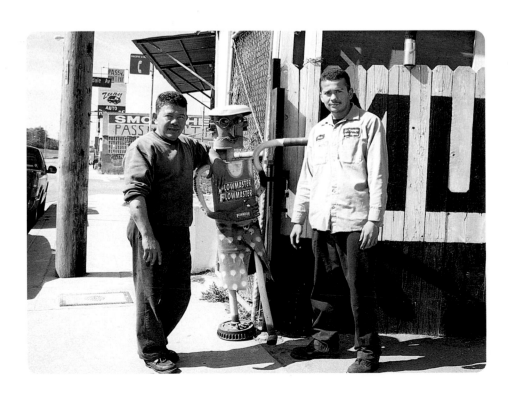

Oh, it's a muffler shop.' It gets you more publicity…. Every muffler shop has them."[21]

Notable for its attention to realistic detail, Salvador and Yasir's sculpture, with its welding-rod eyeglasses, mustache, and articulated hands, captures the attention of passing traffic (fig. 2.40). The men are proud of the effort they put into the creation of their shop mascot. Seeking verisimilitude in their portrayal of a humanlike entity, father and son spent two hours on each of its hands (fig. 2.41). They carefully sculpted the joints of the fingers using individual pieces of metal tubing and then made it still more realistic by adding lifelike fingernails.

Since the moment the figure was first put on display, it has successfully sparked the curiosity of onlookers. As Yasir recounts, "People look at it, they stand by it, little kids try to play with it." Some individuals, amused by its creative ingenuity and artistic elaboration, have offered to purchase the artwork. Salvador and Yasir steadfastly refuse to part with their emblem and, instead, routinely offer to make original pieces for those who inquire about the sculpture. As a result, the two men have manufactured and sold more than twenty works to various customers who have periodically asked them to build statues.[22] One individual, for example, specifically requested a muffler woman and a muffler dog for use as yard decorations (fig. 2.39). Yasir and Salvador carefully fashioned the woman's facial features: wide, ruby-colored lips; thick eyelashes and eyebrows; and amply rouged cheeks. Long curvy hair made from strips of wire flows down the back of her catalytic-converter head, and earrings made from keychains that once bore the muffler shop's logo dangle from her ears.

Like most mechanics who produce muffler sculptures, the two men accomplish the assembly of new pieces in stages (fig. 2.43). Noting that it takes

2.38 Salvador Flores and Yasir Flores with La Tortuga Muffler Man by Salvador Flores, Yasir Flores, and Adrian Corona, 1993. La Tortuga Auto Repair. Photograph by Correll/Polk, Los Angeles, 1998.

2.39 Muffler Woman by Salvador Flores and Yasir Flores, 1997. La Tortuga Auto Repair. Muffler, catalytic converter, flexible pipe, exhaust tubing, angle tubing, wire hangers, exhaust flanges, ball bearings, spark plugs, paint, and other miscellaneous items. Height 186.8 cm. Collection of Cynthia and David Comsky.

2.40 Detail of Muffler Man's Face (fig. 2.38) before repainting.

2.41 Detail of Muffler Man's Hand (fig. 2.38).

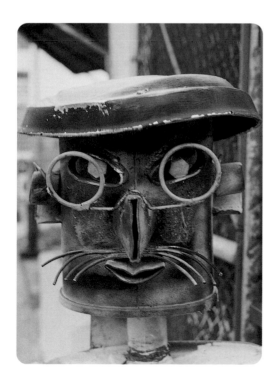

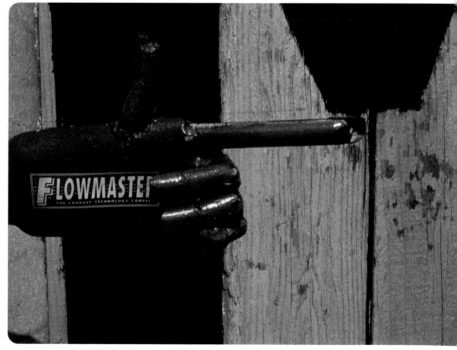

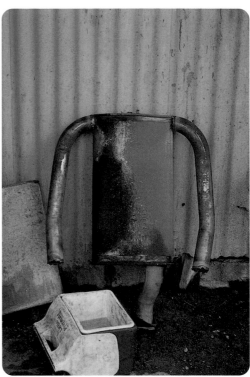

about two and a half months to construct a large figure, Yasir states, "We do it little by little, whenever we have a chance, whenever we're not working, whenever we have the parts to do it." Concerning the ongoing contemplation of damaged parts as potential sculptural components, Yasir remarks, "Whenever we think we can make something out of them, we put them aside." In this manner, parts are salvaged and accumulated based on their perceived artistic applications.

A miniature armored military vehicle Salvador and Yasir built from scrap and then placed in their front office well exemplifies how the shape of automotive parts may propel artistic creativity (fig. 2.42). Its tracks are actually timing chains that, because of their resemblance to the caterpillar tread propulsion used on tanks, prompted the construction of the war machine. Yasir says, "A friend took his engine apart, and in the engine there were some timing chains…. From those timing chains, we decided we could make a tank." Other automotive parts inspired further additions to the creation, including a telescoping cannon, smaller machine guns, and a crewman's head protruding from the turret.

Concerning the process of constructing figurines, Yasir notes, "First what we do is actually look for the body and the base. Then little by little we start getting parts from here and there. Then we start doing the legs, then the face." After the main structural components have been welded together and the facial details added, the final step is to spray paint the figure. Often one of the men will come up with an innovation and then consult the other regarding its appropriateness. Working together, the two mechanics combine "the normal functions of perception, imagination, and contemplation in such a way" that

2.42 Tank by Salvador Flores and Yasir Flores, 1998. La Tortuga Auto Repair. Catalytic converter, timing chains, heat shield, exhaust tubing, angle tubing, wire hangers, exhaust flanges, ball bearings, spark plugs, paint, and other miscellaneous items. Length 76.5 cm. Collection of Cynthia and David Comsky.

2.43 Muffler Sculpture in Progress by Salvador Flores and Yasir Flores, 1998. La Tortuga Auto Repair. Photograph by Correll/Polk, Los Angeles, 1998.

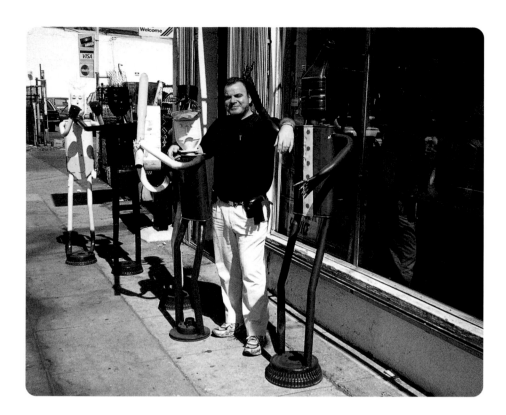

2.44 Frank Afra with Muffler Sculptures. Affordable Muffler and Auto Repair. Photograph by Correll/Polk, Los Angeles, 1997.

damaged auto parts are given special attention (Jones 1971, 84). A new filter of artistic discernment is overlaid onto perception with the tangible features of items being comprehended and conceptualized from alternative points of view. Freed up from the dull constraints of seeing the by-products of work as mere junk, Salvador and Yasir playfully break up the monotony of the daily work experience through creative bricolage as a shared experience between father and son. In addition, sculpting with automotive detritus has become a common work-related activity, one carried out for both fun and profit.

Affordable Muffler and Auto Repair,
1338 South La Brea Avenue, Los Angeles

Until the business closed down in the spring of 1998, workers at Affordable Muffler and Auto Repair produced muffler art on a regular basis. As a result, the shop featured a constantly changing lineup of statues. On any given day, up to one dozen or more works of art lined the sidewalk in front of the business, including sculpted animals, cowboys, an Olympic torchbearer, Santa Claus, and cartoon characters like Gumby (fig. 2.44). Operated by partners Frank Afra and Kal Mekkawi, both of whom were born in Lebanon and emigrated to the United States, Affordable Muffler was notable because of the quantity of works produced at the shop. Between the years 1994 and 1998, Frank, Kal, and their coworkers designed, produced, and sold more than seventy muffler sculptures.

Frank moved to Los Angeles from Vermont in 1994 and was the driving force behind the creation of muffler art at Affordable Muffler. He indicated that he always had a penchant for art and painted landscapes to pass the time

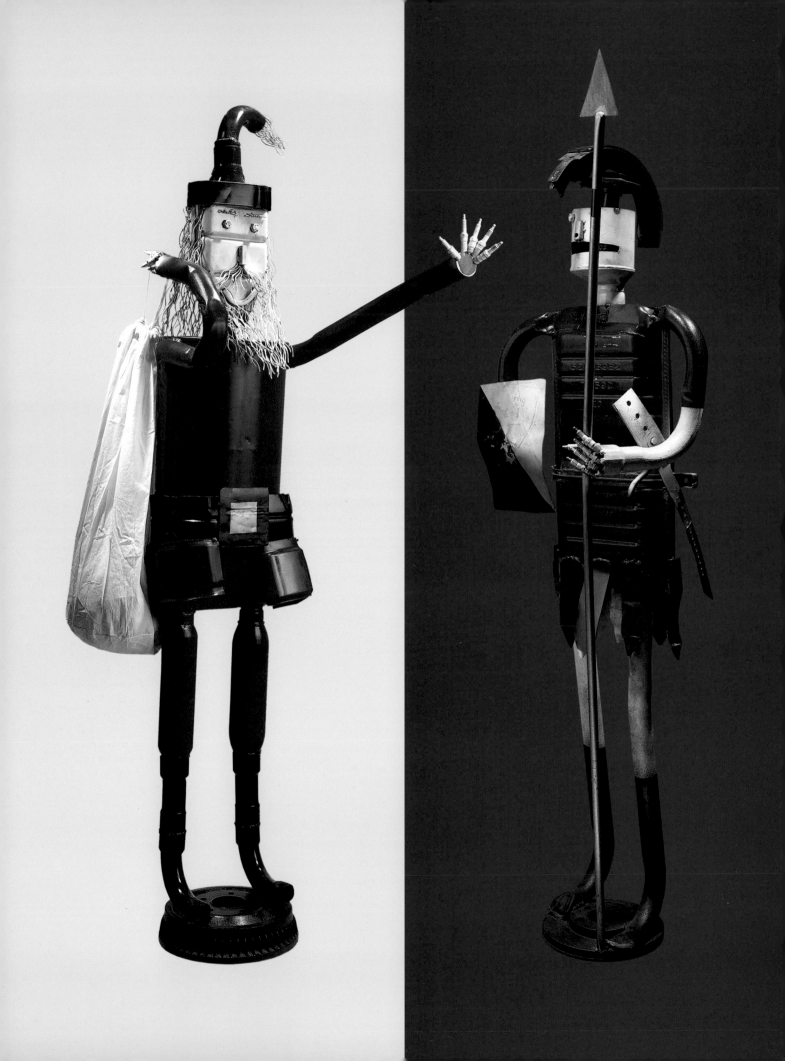

during the long winter months when he was working at an IBM plant in Vermont. When he moved to Los Angeles and entered the automotive repair industry, his artistic medium shifted from painting to sculpting figures using cast-off auto parts. Like most other mechanics, Afra and his colleagues considered their first works to be a form of advertisement. When asked if he thought the horde of sculptures in front of his shop did, in fact, attract customers, Afra declares, "They're bringing [in] business, people are seeing them…. Oh, you won't believe when I had about fifteen of them sitting out there … and I had so much business, I stopped advertising. 'Cause everybody knew Affordable Muffler had all these—they call them in Mexican *muñecos*—art statues."[23]

Like Salvador and Yasir Flores, Frank and his coworkers were offered money for their initial creations. Reflecting back on the first one they sold Frank relates, "This guy comes, pays me fifty dollars for it the next day. So I said, 'This is rewarding; it didn't cost me anything, probably two dollars and some welding, that's it.' The artistic endeavor just flowed [laughs]…. I got a light bulb right here [pointing to head]." Also regarding their sales, he continued, "We had lots, but you see we never thought it would be so rewarding. I mean financially, it was okay. It's good pocket money. But it just mushroomed." As Kal later recalled, "I never thought we would be able to sell them. And I was amazed at the money we were offered. The whole idea was to put funny things outside to get peoples' attention…. And we never thought we were going to get money for them. And when they got money, we were like, 'Yeah, okay.'"[24]

Affordable Muffler's location on a well-traveled section of La Brea Boulevard, just south of the famed Museum Row, proved to be an ideal spot for selling muffler art. Sculptures were simply placed in front of the shop and obligingly sold when individuals offered to buy them. Some of the works didn't even last an entire day before being purchased. In this way Afra and his coworkers practically established a cottage industry at the shop. While Frank, at times, welded the figures himself, more often than not his coworkers and employees assembled the pieces according to hand-sketched blueprints Frank drew. At the request of one customer, Frank began signing his name on the works. Nonetheless, the sculptures manufactured at Affordable Muffler should be viewed as group constructions since they were designed and assembled collectively. Ernesto Ceyvantas, for instance, worked on many of the sculptures as part of his hourly wage, as did other employees. The interactive nature of their collaboration is typified by Kal's discussion of a Santa Claus statue built just prior to Christmas 1997 (fig. 2.45): "This guy Marvin [Rivas] really worked on it. You know, it's amazing. That Santa Claus, we had a certain design to do it. And he fulfilled all the design. He made it the way we wanted it, but then he started getting ideas to put more stuff on it. He did extra stuff, actually."

Although the fabrication of sculptures was a communal endeavor, it was Frank himself who came up with the themes for many, if not most, of the works. Ideas for particular pieces were inspired by personal predilections, life experiences, his immediate environment, or the shape of automotive parts. Because the shop was in close geographic proximity to the campus of the University of Southern California, for example, Frank designed a muffler

2.45 Santa Claus by Frank Afra and Marvin Rivas, 1997. Affordable Muffler and Auto Repair, Los Angeles. Muffler, catalytic converter, wire hangers, nuts, heat shield, exhaust tubing, spark plugs, rear brake rotor, paint, and other miscellaneous items. Height 186.8 cm. Private collection.

2.46 Trojan by Frank Afra and Ernesto Ceyvantas, 1997. Affordable Muffler and Auto Repair, Los Angeles. Muffler, catalytic converter, exhaust tubing, spark plugs, muffler clamp, catalytic converter breather tube, front brake rotor, sheet metal, paint, and other miscellaneous items. Height 184.3 cm. Collection of Mirá Paris International Museum, Primm, Nevada.

replica of the USC Trojan mascot (fig. 2.46). Concerning that particular work, he says, "I had lots of USC students as customers, so it inspired me to make a Trojan, 'cause USC is right here.... I had lots of USC students come in and say, 'That's a beautiful Trojan.'"

Frank also developed a series of statues depicting prizefighters, because "his employees were always talking about them," and a large Gumby statue due to the fact that he used to enjoy watching the animated show with his children. He also claims to have constructed seven cowboys, a popular theme among muffler sculptors, during the period he operated Affordable Muffler. When asked why he started making cowboys, Frank first responded, "I lived in Dallas, Texas. I worked for a corporation. On Friday... the employees had to dress like cowboys. So I invested in lots of Western wear for my job. Then I was inspired." In addition to being "inspired" by his costuming in Texas, Frank further indicated that he was "very fascinated" by cowboys as a child and often drew pictures of them. As Robert McCarl notes, elements of the occupational life of a work group "are fragmented, inverted, and continually mixed with outside concerns of a popular, familiar, and ethnic nature (to name a few) that interact with the work context by constantly borrowing from and adding to it" (1978, 158).

At Affordable Muffler, damaged auto parts were often saved because they fit into preconceived design typologies: catalytic converters were set aside to make heads, mufflers for bodies, exhaust pipes for limbs, hangers for hair, and spark plugs for fingers. Heavy wheel rotors were retained to use as sculpture bases. Various types of automotive debris also prompted ideas for new designs; in Frank's words, "Sometimes the shape will give me the idea." Reminiscing about the source of inspiration for one muffler animal, he recalls, "I remember this guy came in, his car engine backfired, it blew the muffler, the muffler was new.... When it exploded it made a shape of an animal, the belly and everything.... When it cracked it made ribs here.... When I looked, I said, 'Ooh, this will make a good animal.'" The shape of another damaged auto part also sparked Frank's imagination. Holding up a piece of metal he intended to use as the head for a character from the Wizard of Oz, he reflects, "First thing I took it out—this came from a Volvo—I said, 'I'm going to make a Tin Man.'" The level of artistic discernment through which muffler artists reinterpret the materials of work is well encapsulated in Frank's comment about a type of blown-out muffler that motivated him to make a series of muffler cats: "They are the worst design for an exhaust system on a car. I hate them, but for statues they're perfect."

Normally, Frank would think of an idea for a sculpture, generate an image of it in his head, and then draw it out on a piece of business letterhead or a scrap of paper. Frank's wonderfully detailed sketches uniquely document the convergence of his comprehensive knowledge of automobile parts and his flair for artistic design. Illustrated using different colors of ink, the renderings contain not only line drawings but also itemized lists of the parts needed to fashion the sculpture as first envisioned (fig. 2.47). The process of design also involved creative problem solving. Frank, for instance, found it difficult to make rounded

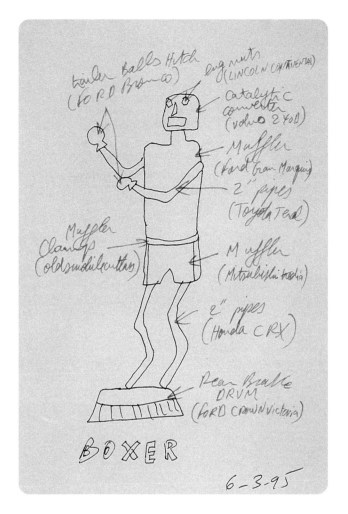

2.47 Design for Boxer Sculpture by Frank Afra, 1995. Affordable Muffler and Auto Repair, Los Angeles. Collection of the artist.

boxing gloves for his prizefighters, so he bought real ones and attached them. These were stolen, so he had to come up with another plan. Eventually, he decided to use ball hitches for hauling trailers and had one of his mechanic's locate some at a junkyard.

Both literally and symbolically, the statues Afra and his coworkers created are microcosms of the repair work done at Affordable Muffler. Once he had drawn up a design, Frank would wait for specific types of automobiles to arrive in order to acquire the necessary components. As time passed and more vehicles were serviced, he gathered the used parts that would enable the sculpture to be completed. Concerning the Trojan, he says:

The Trojan took me about three months to finish. I needed lots of materials. Because this [points at body of the Trojan on a sketch] came from a Jeep Cherokee, and I didn't have a Jeep Cherokee muffler to change in a long time … I waited and waited and waited. I had all the material except that muffler. It's perfect for a body for a Trojan, because it looks like armor…. It has lines on it, it looks just like armor…. So [when] somebody came in [needing a new Jeep Cherokee muffler], I said "Whoo!"

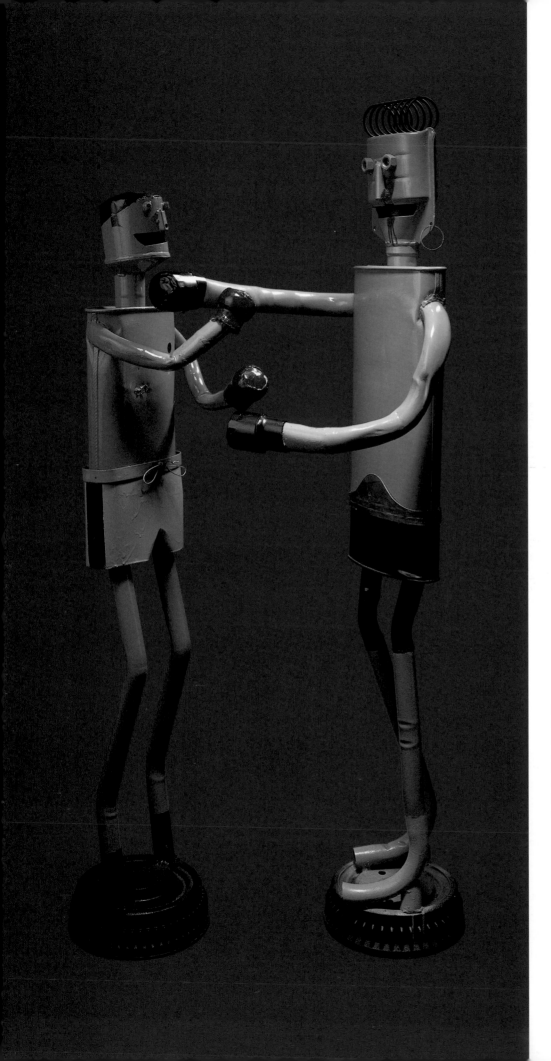

2.48 Boxers by Frank Afra and Ernesto Ceyvantas, 1995. Affordable Muffler and Auto Repair, Los Angeles. Mufflers, catalytic converters, ball hitches, exhaust tubing, muffler clamps, rear brake drums, exhaust heat shield, wire, springs, paint, and other miscellaneous items. Height (1) 153.8 cm; (2) 172.8 cm. Collection of Mirá Paris International Museum, Primm, Nevada.

In some instances, damaged parts arrived that, although not specified in designs, proved ideal for certain features Frank had imagined. Such is the case with the brake shoe from a recreational vehicle that was used for the crest of the Trojan's helmet. As Frank recalls, "We had an R.V., a recreational vehicle, and it had big brake shoes.... When my mechanic took it out, I said, 'This is it, it's perfect for the helmet [laugher]!'" The shape of parts also suggest creative elaboration of the original design. When Afra was asked why there was an earring on the bloody-faced boxer he created, he pointed out that it was not in his blueprint: "The catalytic converter, the way it was shaped, I looked, I said, 'Perfect, put an earring in there!'" A transmission seal, now re-envisioned as an adornment, was then dangled from the hole in the metallic lobe. As Charles and Janet Dixon Keller note concerning blacksmith work, there is a kind of playful duality involved in the process of construction consisting of an "internal, mental and external active side." Imaged goals are reorganized and creatively elaborated as the contingencies of construction are attended to, and as aesthetic sensibilities come into play (1993, 128–29).

Many of the sculptures Afra designed incorporate human accessories as a "finishing touch." A Santa Claus carried an old workplace laundry bag stuffed with empty tin cans as his satchel of gifts and, as noted, his first prizefighter wore real boxing gloves. Figurines produced at Affordable Muffler are notable for their realistic details: boxers with blood dripping down their faces; tie strings on their boxing trunks; and gold belts, belly buttons, and nipples (fig. 2.48); and cowboys with guns, kerchiefs, and badges. When we asked Frank why a number of the figures have cigarettes or pipes in their mouths, he responded that "It will give them character. General MacArthur smoked— remember the corncob pipe? It gave him character." Taking this aesthetic proclivity even further, Frank brought one sculpture to life by making it appear to be smoking a real pipe. He says, "One time I took my mop, my old mop, we have lots of chemicals on the floor.... So this thing, you cut it, you put it in the [muffler man's] pipe ... you light it, it keeps burning, because of the chemicals in there.... So I put one outside [laughing]. It was smoking all day, and people were so fascinated."

Referring to the sculptures as "exhaust art," Frank gained a great deal of artistic gratification from the attention he received. Over the two years we were in contact with him, he constantly emphasized recycling as an important aspect of the production of muffler art. He notes, "I saw my exhaust mechanics taking the junk we take off cars and putting it outside. I was looking outside, I said, 'That's lots of waste.'... So I said, 'I can do something, I can make something out of this metal.'... All these things are going to go into a garbage dump and they are going to sit there for a thousand years. So why not make useful art out of them?"

People stopped at Affordable Muffler on a daily basis to talk with workers about the sculptures on display. Frank says, "I got lots of compliments. People were impressed. Everybody asks me the same questions: 'Where did you get your material? Which car did this come from?'" Frank relished his role as a muffler artist; in particular, he enjoyed meticulously identifying the make and

model of the car from which each part used in a sculpture was derived. When we told him that several of the works produced at the shop had sold were now displayed in an art gallery, he smiled triumphantly and said, "I finally made it in a museum!" Referring to the exhaust art he has sold, Frank states, "I made a rule for myself: I won't fall in love. I will fall in love with the idea, but I won't fall in love with the material thing.... I can always make more."

G & R Muffler, 19065 Grand Avenue, Lake Elsinore

On some days, the paved area in front of G & R Mufflers is the focus of considerable activity, some of which is only indirectly related to the automotive repair work being done at the shop. Motorists turn in off of Grand Avenue and stop their automobiles. Sometimes drivers get out and stretch their legs; at other times, they linger in their vehicle for a brief while and then pull away again. Clients waiting for a repair job to be finished or those who are seeking estimates may wander out of the garage's small office, preferring instead to wait outside. Pedestrians, including children from a nearby school, pause and spend a moment or two near the shop's facade. Although G & R Mufflers has a well-deserved reputation for its quality muffler work, there is also something else about the shop that attracts people to it: the presence of what has been referred to by some as the "Lake Elsinore Muffler Family" (fig. 2.49).

2.49 G & R Mufflers. Photograph by Correll/Polk, Lake Elsinore, California, 1998.

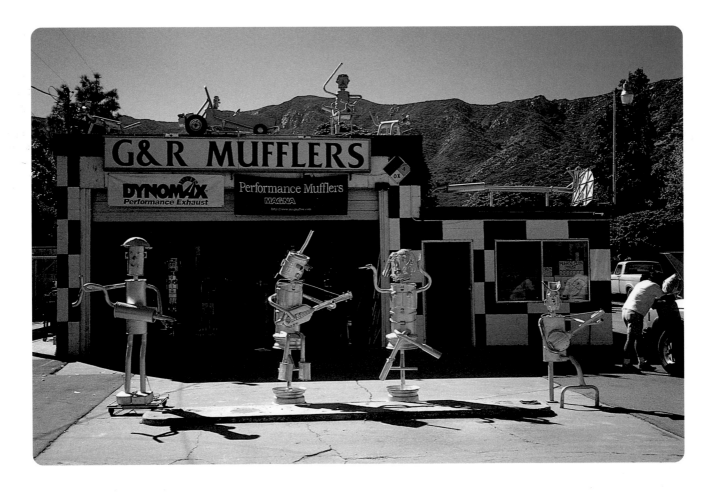

Owned by Gary Koppenhaver, who runs the business with the help of his friend Duncan (Turp) Turrentine, G & R Mufflers features no less than ten silver muffler sculptures. Six of these works—three men, two women, and a rocket man—are displayed in various places in front of the shop. The other four works—two dogs, a race-car driver, and a man in a chair—have been secured to the roof of the building. This crowd of muffler sculptures has a definite effect on passing traffic; according to Gary, "People stop in all the time. They always go out and look at them." Further, he notes, "Twelve years ago when I first came here it was something new for people. So a lot of people were stopping by with their kids."

Because of the popularity of his artworks, Gary is widely referred to by locals as "The Muffler Man." As if to further assure the synthesis of his occupational identity with the creation of muffler art, the logo printed on his business cards, customer receipts, and his office clock bear the image of one of his first sculptures (figs. 2.50, 2.51). Gary enjoys making the statues because they give him an additional opportunity to be creative. He has also crafted other art objects, such as miniature trucks and cowboys made out of horseshoes (fig. 2.52). Duncan, who is also Gary's partner in the construction of sculptures, has likewise manufactured other types of welded art, including a Lilliputian Ferris wheel complete with moving parts (fig. 2.53). Gary first made a muffler sculpture when he was employed at a repair business in

2.50 Gary Koppenhaver and Duncan Turrentine with Muffler Man, 1985. G & R Mufflers. Photograph by Correll/Polk, Lake Elsinore, California, 1998.

2.51 Business Card for G & R Mufflers. Lake Elsinore, California.

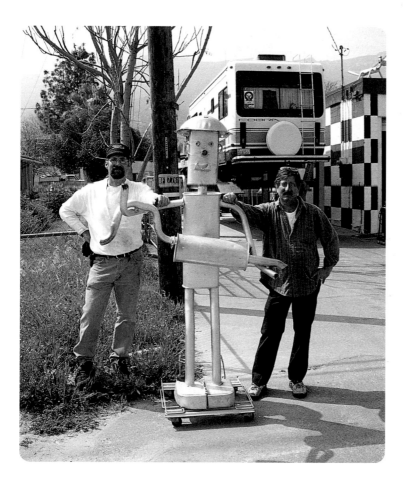

Hawaiian Gardens. Unfortunately, his employer at the time frowned on the production of such objects; according to Gary, he "didn't even want it in front of his shop." Later, when Gary opened his own garage, he made another muffler figure. "I thought, 'Now I can make my own muffler man and nobody's going [laughing] to throw it away,'" says Gary. "I'm my own boss [and] I can do this if I want to." Reflecting on the sentimental value of the statue, he notes, "I wouldn't get rid of that guy, 'cause that was kinda like my first one, you know."

Although numerous passersby have offered to purchase the sculptures on display at G & R Mufflers, Gary and Duncan prefer not to sell the works. Over the years, however, they have been persuaded to part with several pieces. Gary reports, "I've sold a couple of them—a guy riding on a skateboard, a golfer we made.... We had a dog we sold [that was] up on the roof here. We sold that to a lady up on the hill. She's got it sitting in her house next to her couch. Got it for her husband [because] he wanted it for his birthday." Furthermore, adds Gary, "They had to talk us into it, because we didn't feel like selling them, didn't make them to sell them.... 'Cause really that's us making that, mind-wise and feeling-wise."

Gary and Duncan indicate that the sculptures they have manufactured generally evolved out of impromptu moments of artistic vision; a process greatly facilitated by the mound of used parts they have accumulated. As Gary notes, "When we're just walking around and not doing something, which is not too many times, but when we do, we just go to the [muffler] pile and stand there [looking]." Says Duncan, "You gotta see them, if you don't see them in the pile, you don't make them. You just gotta see 'em.... You just get a whole bunch of junk mufflers, and all of a sudden something just catches your eye and you go, 'Yeah I'm going to make something out of that.'"

2.52 Miniature Truck by Gary Koppenhaver, 1976. G & R Mufflers, Lake Elsinore, California. Hammered exhaust tubing, washers, hanger bolts, and scrap metal. Length 14.8 cm. Collection of the artist.

2.53 Miniature Ferris Wheel by Duncan Turrentine, 1987. G & R Mufflers, Lake Elsinore, California. Welding rods, nuts, bolts, scrap metal, and paint. Height 38.1 cm. Collection of the artist.

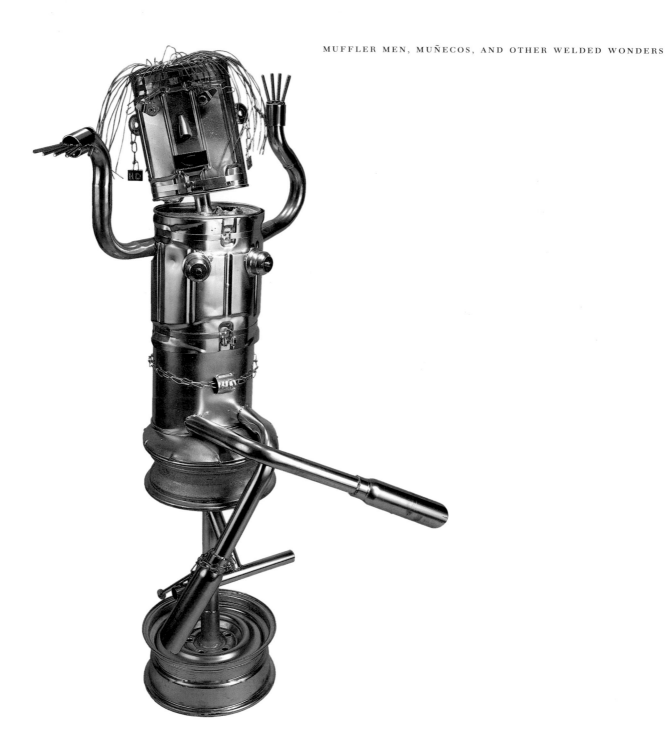

Although ideas for sculptures may derive from sudden flashes of inspiration, it can take lengthy periods of time to complete a piece. Gary, who often contemplates the construction of a piece long before he actually begins assembly, states, "We just can't use like any muffler to get an effect of something. So we kinda just put a few aside. I just made a new guy here in the office I'll show you. I made him the other day. I've had the mufflers for six months, but I just had to think about what I wanted to do." Although they may proceed based on a conceptual plan that has existed for some time, Gary and Duncan also rely on creative spontaneity to deal with the exigencies of construction. When asked to what extent he and Duncan rely on their preconceived designs when they build sculptures, Gary responds, "[It's] just kinda in your mind and looking at

2.54 "Harley Davidson Biker Babe" by Gary Koppenhaver and Duncan Turrentine, 1998. G & R Mufflers, Lake Elsinore, California. Mufflers, exhaust tubing, muffler clamps, welding rods, trailer hitch spacers, bumper shock brackets, catalytic converter plugs, springs, bolts, chain link, paint, and other miscellaneous items. Height 190.8 cm. Collection of the artists.

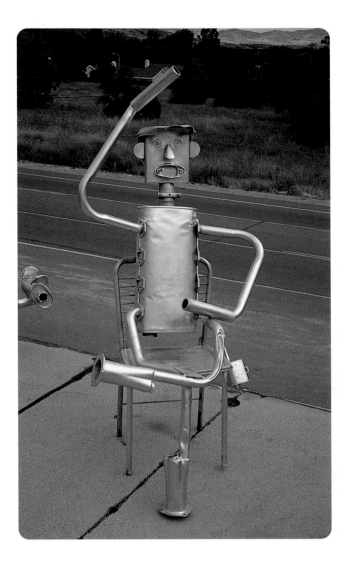

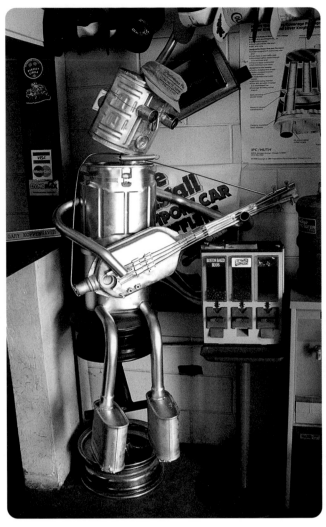

the muffler and thinking how you're going to put it together and what you're going to do. And once you start, spur of the moment stuff, what looks good."

Thus, starting with a general concept and having gathered up all of the parts they think might work as design components, Gary and Duncan proceed by letting imagination take over. Gary notes, "When you start making it you see stuff in your mind, and you go, 'Hey, that would look good.' And if it doesn't look good, you think of something else…. It's just kind of fun to make up, and you just keep going. It's kinda like making a cartoon on a piece of paper."

Gary and Duncan place great emphasis on trying to find the "perfect" part for each of the sculptural details they have in mind. In discussing a muffler woman they created, Gary said, "We put probably seventy noses on her…. It just didn't come out right. I finally said, 'No, we just have to make something if we want a slender nose'" (fig. 2.54). Further describing their method of working together on a project, Duncan says, "He [Gary] bends, I pose, and he bends a pattern. 'How's this, how's that?' I'm the model, I guess…. For this one [pointing to a cowboy sculpture], I just had to stand here and look at myself, 'How am I going to play the guitar?' Okay, I'll bend it this way, and

2.55 "John" by Gary Koppenhaver and Duncan Turrentine, 1988. G & R Mufflers. Photograph by Correll/Polk, Lake Elsinore, California, 1998.

2.56 "Bass Guitar Player" by Gary Koppenhaver, 1998. G & R Mufflers. Photograph by Correll/Polk, Lake Elsinore, California, 1998.

bend it this way. It's easier when some guy's posing for you [laughter], even if you look kinda weird." Summing up own his feelings about the process, Gary exclaims, "We get a kick out of it, we'd talk about it. Me and Turp are really good friends, so it's nice to make something together."

Two of the sculptures displayed at G & R Mufflers exemplify the fact that handcrafted objects often provide "a way to materialize internal images, and through them to recapture earlier experiences" (Kirshenblatt-Gimblett 1989b, 331). The first figure depicts a man sitting in a chair (fig. 2.55). Stationed on the roof of the shop, the sculpture immediately captures the attention of onlookers. When we asked Gary to tell us about the piece, a slight smile appeared on his face and he responded, "Oh, that's John." As an explanation of how the sculpture came to be so named, Gary said it was patterned after a former acquaintance and then related the following story:

> He's painted silver, but he was a Black guy. And he lived in the back
> house back here and he used to come out here, a retired old guy,
> smoked a big fat cigar and just kinda chewed the fat with everybody
> else, with all my customers, a public relations guy. He didn't even
> work here. So when he died I made that guy.... [W]e made him,
> 'cause we kinda missed him out here.

Created as an intimate portrait, the sculpture memorializes John, their deceased friend. Using mufflers, exhaust pipes, and other automotive parts, Gary and Duncan fashioned a monument that serves as a permanent reminder of the most endearing aspects of John's personality. Like the real John, the muffler figure smokes a cigar and waves to passing traffic. As Michael Owen Jones writes, "[T]he loss of a friend, a relative, or one's own health fosters introspection, which may in turn promote the production of a song, story, or other work.... [E]xpressive structures and objects that one creates fill the void caused by loss" (1989, 192). Summing up his conception of the statue and its meaning for him, Gary declares, "Yeah, he's John. Yeah, he's still up there."

The second sculpture is a remarkable statue depicting a musician playing a guitar (fig. 2.56). Seated on a cushioned chair made from used wheel rims, the muffler man has a baseball cap advertising a local business, placed jauntily on his head. His goggle-eyes are focused downward, looking toward the strings of his instrument, which is a tribute of sorts; according to Gary, "I knew this would be kind of like a Paul McCartney-style bass guitar. You remember Paul McCartney. Maybe that's what I made it after." Although similar to the bass used by the former Beatle, Gary did not intend the statue to be a representation of McCartney. Rather, the form of the work was influenced by Gary's own memorable experiences as a both a musician and music fan.

This sculpture was also in part patterned after a man who performs in the same musical group as Gary. With a wide grin, Gary recounts:

> I kinda maybe modeled it after a buddy of mine named Paul. He's
> our bass guitarist, and that's why it's a bass. He's a tall guy. He puts

on glasses now and then. Won't admit to it, so I put glasses on it. So I kinda made it after him a little bit. In fact, I have one of his business hats I put on him…. So when he came in one day, I said, "There you go, that's you" [laughter]. He just kinda chuckled. And he doesn't have any hair on his head so we didn't put any hair on it [laughs].

Asked why the guitar player appears to be wearing elevator shoes, Gary laughingly reminisces, "In my childhood days in high school, I went to see Sly and the Family Stone. Back then, 1968, 1970s, platform shoes were around. And there was this guy in the crowd, he was a short guy. He was kneeling down but he has shoes this tall." Years later when he began work on the sculpture, Gary flashed on the striking image of the diminutive man and his extraordinary footwear. He says, "And I remembered that guy and I said, 'Hey that would be kinda cool out of mufflers.'"

The work acts as a repository or metonym for Gary's own life experiences. As Christopher Musello has noted, "The things with which we surround ourselves, may, and commonly do, become inscribed with multiple valences of significance, with each level of meaning modifying the other" (Musello 1992, 37). The process of artistic creation enables Gary and Duncan to express, among other things, personal interests, nostalgic memories, and joking relationships; meanings that often go unarticulated or are only shared among members of his immediate group of coworkers and friends.

Although the sculptures are inscribed with esoteric knowledge, their stylistic details can be readily appreciated and enjoyed by anyone who passes by the shop. Describing why he believes the muffler art appeals to a wide audience, Gary relates, "I think all people get a kick out of it, kinda the kid thing in their mind…. People always look for something to be happy about. There's so many weird things in the world … it's kinda neat to look at something that's comical and get a chuckle, 'cause laughing is good anyway. [It's] something they can relate to in their childhood, just like a toy."

The sculptures at G & R Mufflers prompt a variety of communication between Gary, Duncan, and various passersby. Shop customers or other individuals, for instance, try to join in the creation, decoration, and display of muffler sculptures by making practical or imaginative suggestions. Describing the time he and Gary were crafting a muffler woman, Duncan says, "Everybody else that came in had ideas, you had to tune them out." Likewise, Gary laughingly reports an exchange he had with one of his neighbors concerning a rocket man muffler sculpture: "The lady up the street wants to come down and put a cape on it. She said, 'I've been thinking the last couple of months of putting a cape on that guy.' I said, 'Well, if you climb up there, don't get hurt [laughter].'" After watching Gary laboriously drag one particular muffler sculpture out in front of his shop each morning, another neighbor gave him a wheeled cart to use so that he wouldn't have to work so hard putting out the statue. Gary remembers, "He saw me walking it out everyday [and said], 'Hey I got something for you.'"

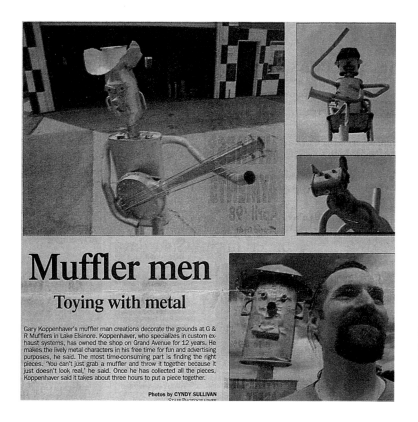

Muffler men

Toying with metal

Gary Koppenhaver's muffler man creations decorate the grounds at G & R Mufflers in Lake Elsinore. Koppenhaver, who specializes in custom exhaust systems, has owned the shop on Grand Avenue for 12 years. He makes the lively metal characters in his free time for fun and advertising purposes, he said. The most time-consuming part is finding the right pieces. "You can't just grab a muffler and throw it together because it just doesn't look real," he said. Once he has collected all the pieces, Koppenhaver said it takes about three hours to put a piece together.

Photos by CYNDY SULLIVAN

2.57 Newspaper Article Featuring the Sculptures of G & R Mufflers. "Muffler Men: Toying with Metal," *The Californian* (Friday, October 10, 1997).

Events that occur as a result of the presence of the muffler sculptures are related by Gary and Duncan to coworkers, family members, friends, and others. In this sense, the figures become "storage symbols"(Musello 1992, 47). As Mussello notes, an item may function, in part, as mnemonic device that serves as an "adjunct to storytelling.… [T]he history it encodes … is retained in memory and released through the talk the object occasions or facilitates" (Musello 1992, 48–49). The following events, for example, were narrated not only to us but also to other individuals who have interacted with Gary over the years·

> We had a dog sitting out here one time, a guy was walking down the
> street with his Rottweiler, a big dog. And the dog came walking by
> and he tells him to get him. And this dog will actually come up and
> bite the throat on that little metal dog out there [laughter]. An old
> lady came by here one day walking her dog. The dog took a second
> take [and] started barking at it. She had to hold it back. And she's just
> laughing. "Man," I said, "I wish I had a movie camera for this stuff."

Gary often tells the story to customers when they ask about his muffler dog, "Kind of a little story, you know, 'One day when this dog came by.' They get a kick out of it."

Over the years, Gary and Duncan's works have been featured in four local newspapers (fig. 2.57). Buoyed by this and other forms of community recognition he and Duncan have received, Gary vows, "We're going to make

something just for the town to look at…. I'd like to do a whole bunch of them. Just for people [to say], 'Hey, have you seen this guy's shop, fifty muffler men standing out in front.' Eventually, that's what I'd like to do, if I'm still here, just for fun."

◆ ◆ ◆

Muffler art allows individuals to personalize their workspace and communicate socially through a distinctive form of self-crafted artistic expression. While the creation of muffler sculptures for advertisement is a widespread practice, the significance attached to any given work is the result of a confluence of unique circumstances. Muffler sculptures inspire communal creative activities, as well as group play, and incite a variety of interactions between passersby and the artists. For this reason, individual muffler men, or *muñecos*, may take on a multiplicity of meanings based on any number of idiosyncratic factors. Individual predilections, personal experiences, and face-to-face interactions inform and are constructed around these sculptures, serving to imbue them with esoteric and symbolic significance.

Although this study has focused on the tradition as it is inflected at four locations in Southern California, the behaviors found at these workplaces are not entirely unique. We have documented many examples of collective construction, community interaction, the production of art for profit, and the "repair shop as gallery" display aesthetic. As an occupation-wide tradition, this medium provides a framework that enables self-expression to flourish. The crafting of muffler art presents challenges that evoke and evince imaginative creativity, innovation, and skill resulting in satisfaction with completed works. Designing and assembling sculptures alters the cognitive processes through which individuals discern their work materials and the skills and tools of their vocation. Such consideration of automotive detritus from alternative points of view results in what C. Kurt Dewhurst refers to as the "playification of work" (1984, 192).

Time after time we have found that muffler sculptures prompt social interactions that would not otherwise occur. As Sojin Kim argues, "People create their physical surroundings not simply in the structures they build or adorn. They also shape and give spaces meaning through the ways they interact and use them" (1997, 13). Increased sociability and camaraderie in the workplace emerges out of the processes of design, construction, and display of muffler art. As the public begins to respond to the sculptures, praising them, offering to buy them, and celebrating them in local newspapers, a stronger sense of emotional connectedness develops among coworkers, as well as with the wider community in which they work (Jones 1995, 265). Inscribed by events through time, the figurines become "nostalgic embodiments"(Jones 1995, 260) for a range of associations and reminiscences for both artists and audiences alike. ◆

2.58 Martian Dog by Ernesto Ceyvantas, Octavio Franco, and Victor Lopez, 1998. Lincoln Auto Repair and Muffler, Santa Monica. Catalytic converter, resonator muffler, exhaust tubing, automatic transmission clutch, exhaust gaskets, spring compressor holder, spare tire bracket, rubber hoses, paint, and other miscellaneous items. Length 67.3 cm. Private collection.

2.59 Space Woman by Ernesto Ceyvantas, Octavio Franco, and Victor Lopez, 1998. Lincoln Auto Repair and Muffler. Photograph by Correll/Polk, Santa Monica, 1998.

2.60 Rocket Man by Gary Koppenhaver, 1995. G & R Mufflers. Photograph by Correll/Polk, Lake Elsinore, California, 1998.

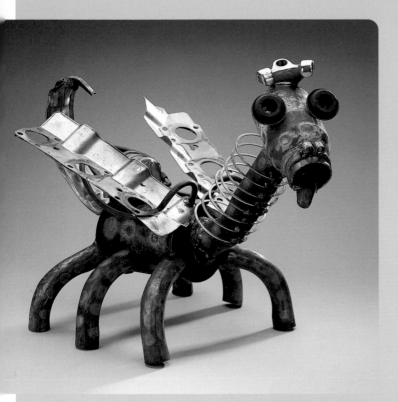

Out of this World
Aliens, Robots and Rocket Men

Automotive components readily lend themselves to the creation of automatons and other creatures from science fiction. Whether inspired by popular images of extraterrestrial life or dreams of escape from mechanical drudgery, these works stir the imaginations of sculptors and audiences alike.

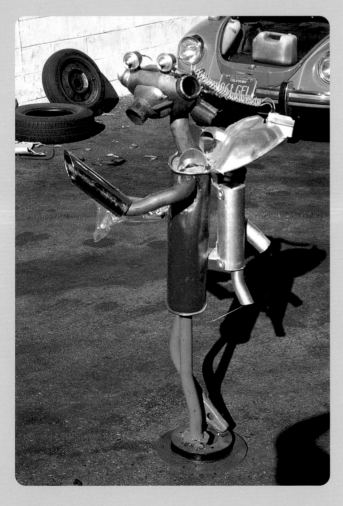

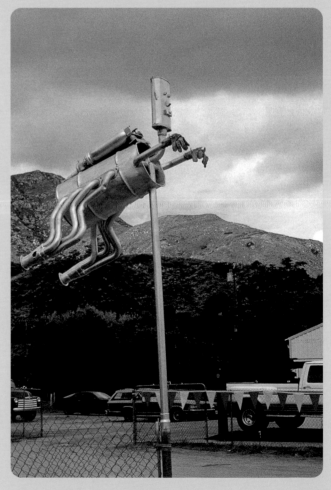

73

2.61 Space *Muñeco* with Baby by Miguel Gutierrez, 1998. AAA Mufflers and Radiators, Los Angeles. Catalytic converter, standard muffler, resonator muffler, exhaust tubing, chrome exhaust tip, wheel rim, advertising decal, decorative ribbon, and paint. Height 128.7 cm. Private collection.

2.62 Robot/Alien by Ernesto Ceyvantas, ca. 1999. Lincoln Auto Repair and Muffler, Santa Monica. Standard muffler, resonator muffler, exhaust tubing, exhaust manifold shield, automatic transmission clutch, thermostatic air cleaner hose, rear brake drum, brake proportioning valve, paint, and other miscellaneous items. Height 160.9 cm. Private collection.

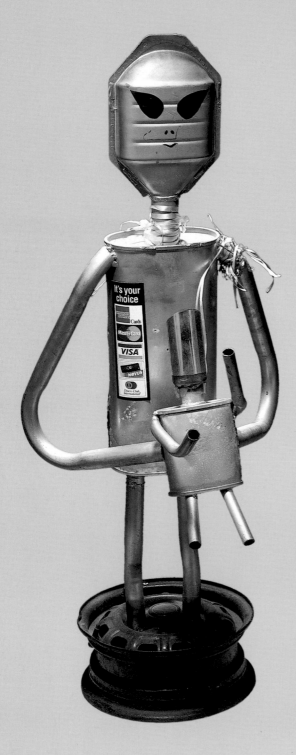

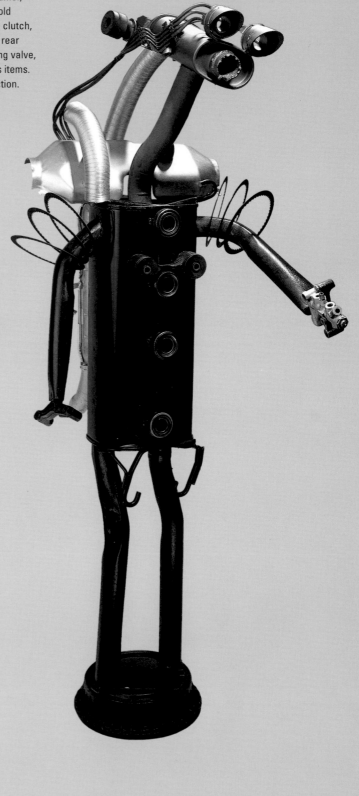

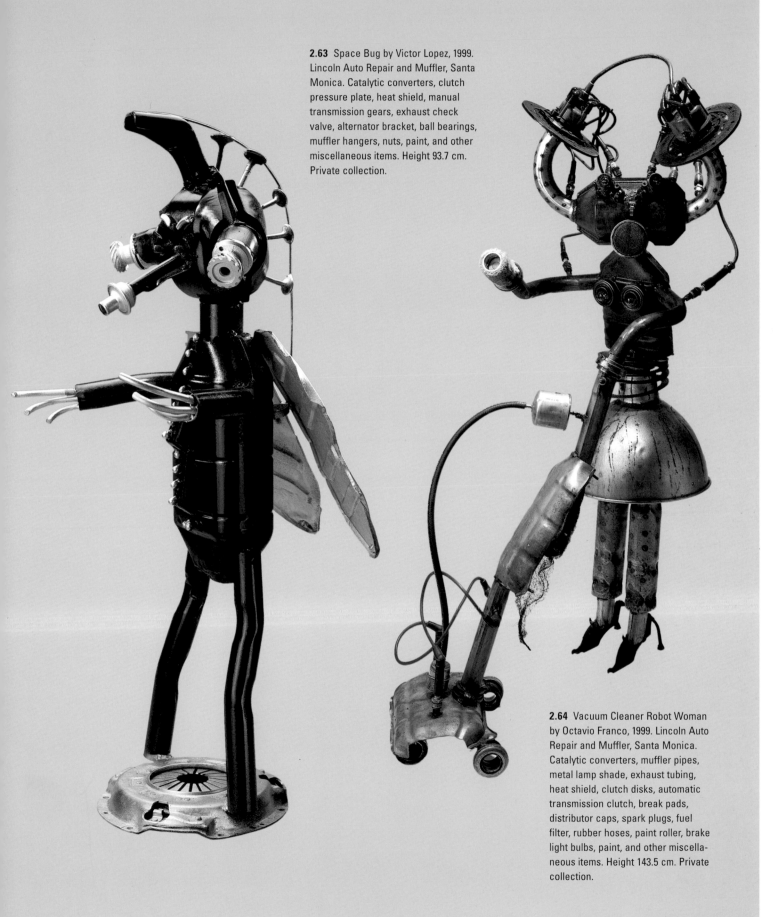

2.63 Space Bug by Victor Lopez, 1999. Lincoln Auto Repair and Muffler, Santa Monica. Catalytic converters, clutch pressure plate, heat shield, manual transmission gears, exhaust check valve, alternator bracket, ball bearings, muffler hangers, nuts, paint, and other miscellaneous items. Height 93.7 cm. Private collection.

2.64 Vacuum Cleaner Robot Woman by Octavio Franco, 1999. Lincoln Auto Repair and Muffler, Santa Monica. Catalytic converters, muffler pipes, metal lamp shade, exhaust tubing, heat shield, clutch disks, automatic transmission clutch, break pads, distributor caps, spark plugs, fuel filter, rubber hoses, paint roller, brake light bulbs, paint, and other miscellaneous items. Height 143.5 cm. Private collection.

Friends, Remnants, Countrymen...

Designed to provoke positive responses from passersby, some muffler sculptures are made to resemble familiar cultural icons, such as clowns and cartoon characters, while others capture the attention of viewers by projecting notions of ethnic identity or national pride.

2.67 Opposite, top left, Clown by Salvador Flores and Yasir Flores, 1998. La Tortuga Auto Repair. Photograph by Correll/Polk, Los Angeles, 1998.

2.68 Opposite, top right, Devil by Jessie Tarula, mid-1990s. Azteca Tire and Muffler. Photograph by Correll/Polk, Los Angeles, 1998.

2.69 Opposite, bottom left, "El Temeraria," mid-1990s. Sinaloa Mufflers. Photograph by Correll/Polk, Lynwood, California, 1998.

2.70 Opposite, bottom right, Gumby by Frank Afra and Ernesto Ceyvantas, 1998. Affordable Muffler and Auto Repair. Photograph by Correll/Polk, Los Angeles, 1998.

2.65 Muñeco by Isauro Ruiz, 1998. Jalisco Muffler Service. Photograph by Correll/Polk, Los Angeles, 1998.

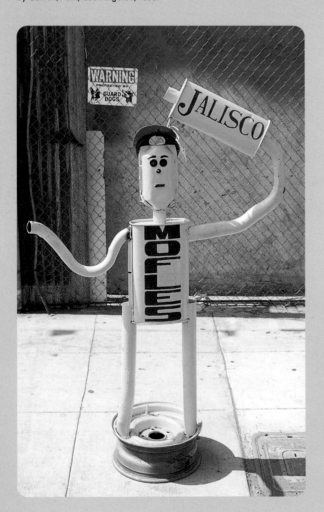

2.66 U.S. Soldier in the Persian Gulf by Kal Mekkawi, 1998. Affordable Muffler and Auto Repair, Los Angeles. Standard muffler, resonator muffler, exhaust tubing, chrome exhaust tip, wheels, bolts, paint, and other miscellaneous items. Height 158 cm. Private Collection.

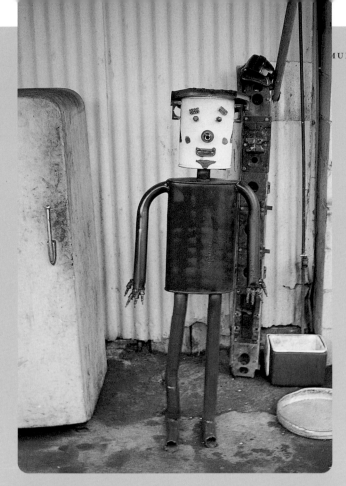

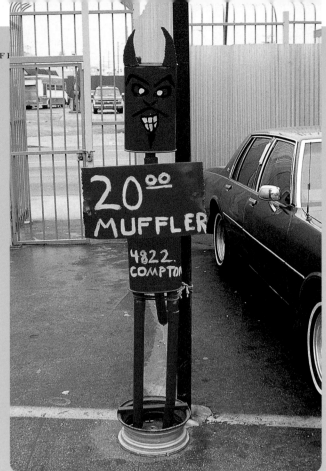

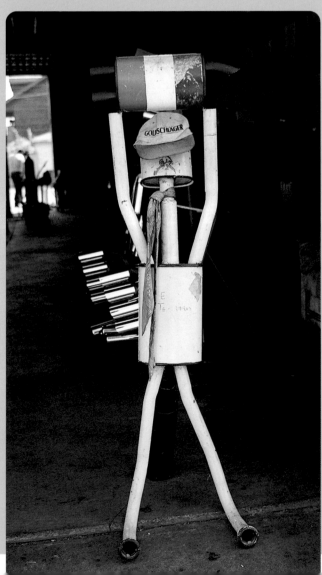

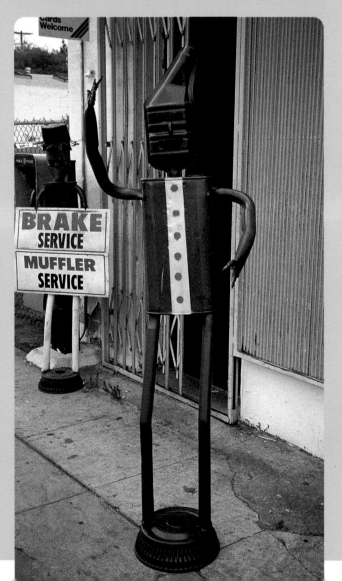

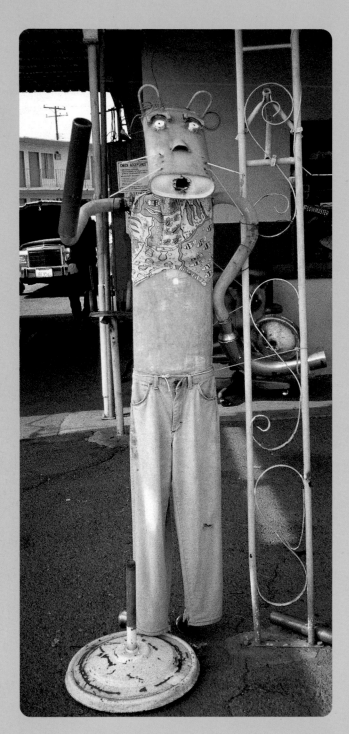

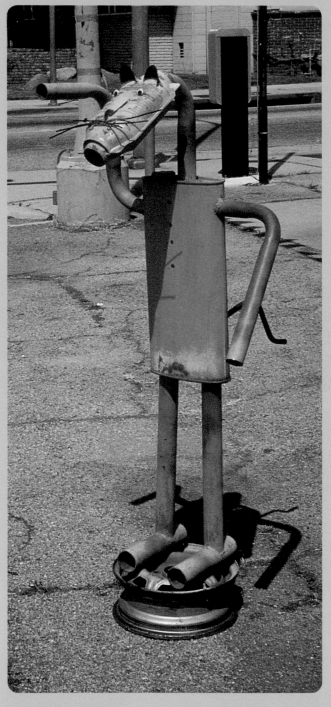

2.71 Female Pink Panther, early 1980s. Mariscal Mufflers. Photograph by Correll/Polk, Downey, California, 1998.

2.72 Pink Panther by Enrique Siru, 1997. Henry's Muffler Shop. Photograph by Correll/Polk, Pasadena, 1998.

2.73 Opposite, "Pepe" (The World Cup Soccer Player) by Francisco Solis, 1994. Lizarde Auto Service. Photograph by Correll/Polk, Los Angeles, 1998.

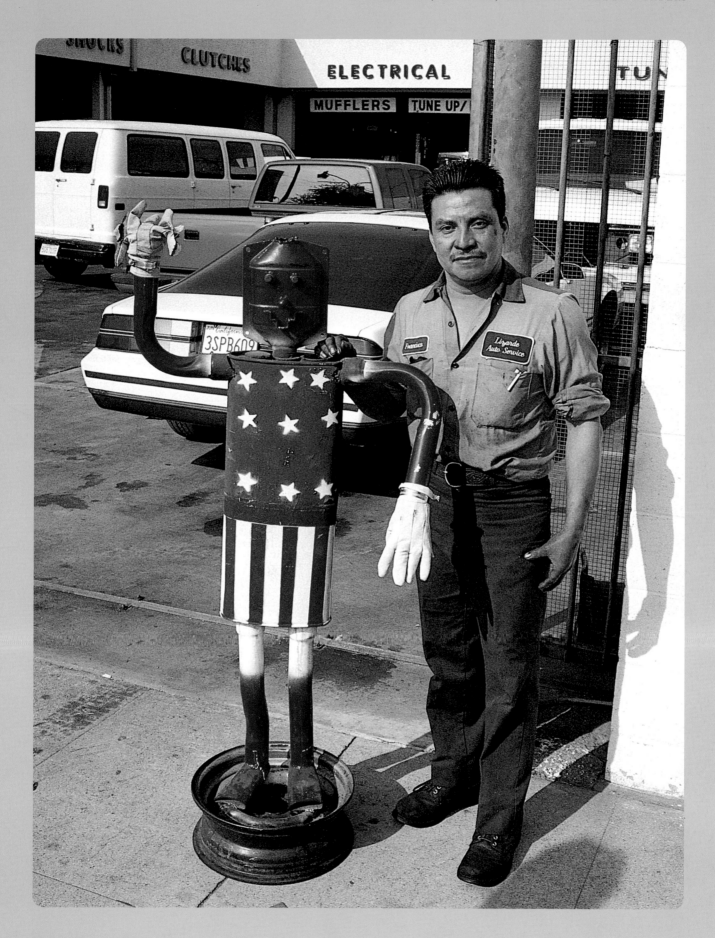

Streetwise

The Mafundi of Dar es Salaam

R. Mark Livengood

Dar es Salaam, Tanzania, spreads out along the Indian Ocean on the East African coast seven degrees south of the Equator (fig. 3.2).[1] The urban hub of the country, Dar es Salaam has a population of roughly three million. A diverse place, the city is home to people representing many ethnic groups of the African continent—approximately 120 groups in Tanzania alone—as well as substantial populations from the Indian subcontinent, the Arab nations, and a smattering of Westerners and East Asians. Similar to major metropolitan areas the world over, the city pulses with a mix of the human

3.1 *Fundi chuma* Mohamedi Athumani Mbombwe and two objects he makes on a regular basis: a balance pan (*sahani ya mzani*) and a ginger teapot (*dele la tangawizi*). In making these two objects Mbombwe used metal that once wrapped coils of steel imported to Tanzania from Japan. Photograph by R. Mark Livengood, Dar es Salaam Small Industries Cooperative Society (DASICO), Gerezani area, September 1997.

3.2 The harbor and skyline of Dar es Salaam, Tanzania. Photograph by R. Mark Livengood, August 1994.

and artifactual. Dar is in perpetual process, dynamically reinvented daily by the oral and material performances of its citizenry, in words and objects.[2]

In Dar es Salaam people called *mafundi* (*fundi*, s.) create and sustain a considerable portion of the city's material life. A standard Swahili-English dictionary defines *fundi* as "a person skilled in any art, craft, or profession, and so able to instruct others in it, a skilled workman, one who has learnt his trade, a trained artisan or craftsman, e.g., mason, carpenter, tailor, smith, washerman" (Johnson 1992 [1939], 103). A Kiswahili dictionary indicates that a *fundi* is a person who has the knowledge or ability to make something, such as a tailor or cobbler.[3] Sidney Littlefield Kasfir, a scholar of African material culture, further suggests that "a *fundi* is an artisan, but the word also carries the connotation of 'one who fixes things.' If my bicycle chain is broken, I take it to the bicycle *fundi*. Also to the point, it may connote a person who has the peculiar skill or talent needed to 'bring things off'" (1992, 49).

Three men who live and work in Dar es Salaam and who identify themselves as *mafundi* have their own definitions of what they do. Mohamedi Athumani Mbombwe, a metalsmith, related that "a *fundi* is any kind of person who has knowledge of the hands. He is able to make [or repair] a thing, for example, a bucket, or a thing which is broken, for example a car or bicycle. This person is called *fundi*" (fig. 3.1).[4] Juma Maulidi Mbande, also a metalsmith,

3.3 *Fundi chuma* Juma Maulidi Mbande and the Land Rover 110 grill (*sho ya gari*) he made from scrap metal. Such a vehicle part has greater longevity than a factory-made plastic part. Photograph by R. Mark Livengood, DASICO, September 1997.

suggested, "There is not a thing which he cannot make [or repair]. This is the meaning of *fundi*" (fig. 3.3).[5] Finally, Celestine Simama, a steel pan maker, says, "*Fundi* is a person who can make things and finish. For instance, a person who sew[s] a trouser. He can cut, make measurements, and sew a trouser, and finish his work according to [how] the customer wants. That is *fundi*" (fig. 3.4).[6] Customarily trained in face-to-face interaction, the *mafundi*, who are typically male, create things. They fix things. They troubleshoot. They are distinctly visible across the sprawl of the city, on nearly every corner, up almost every alley: cobblers (*mafundi viatu*), metalsmiths (*mafundi chuma*), carpenters (*mafundi seremala*), radio repairmen (*mafundi redio*), and men who fix radiators and tire jacks (*mafundi rejeta na jeki*), among many others.

A *fundi* resonates as a *bricoleur* (Kasfir 1992, 49). Claude Levi-Strauss defines a *bricoleur* as "someone who works with his hands and uses devious means" (1966, 16). The use of the adjective *devious* should not be construed as pejorative, however. Instead, the *bricoleur* is devious in the sense that he or she solves problems using available materials. As anthropologist Allen F. Roberts suggests, devious is a "positive reference to the ability and willingness [of the *bricoleur*] to deviate from usual or 'proper'—that is, conventional— courses defined by sociohistorical circumstance" (1996, 85; 1992, 56). The American English slang term *jerry-rigger* expresses the spirit of the *bricoleur*.

3.4 Using scrap 200-liter (55-gallon) drums, *fundi* Celestine Simama makes several types of steel pans for his two steel bands. Here he displays some of the bass pans he has made. Photograph by R. Mark Livengood, Mtoni area, Dar es Salaam, September 1997.

Although a *fundi*, like a *bricoleur*, most often works with "whatever is at
hand," a heterogeneous set of tools and materials (Levi-Strauss 1966, 17),
it is unlikely that the *mafundi* refer to themselves or each other as *bricoleurs*.
They have their own terminology.

For the *fundi*, creating with diverse materials found at hand most often,
but not always, means using the scraps of objects that were manufactured
in places far from the vibrant streets of Dar es Salaam. Such remnants have
already served other functions, had other lives (Appadurai 1990). Because
new materials—metal, car parts, some fabrics—are difficult to come by and
relatively expensive in Tanzania, all kinds of castoffs are collected, bartered,
and sold. City streets supply a steady flow of raw materials, many of which
make their ways to the *mafundi* who turn them into useful things that often
return to the streets from which they came, albeit in different forms. For
instance, some *mafundi* use tires that are no longer roadworthy to make san-
dals, as well as bushings for automobiles and trucks. Because new wood is
expensive, the carpenter supplements his materials cache with shipping crates
and pallet lumber that are available gratis or, more likely, for a small fee.
Other *mafundi* use scrap metal of various gauges—from heavy steel to thin
aluminum—to create myriad objects. The used 200-liter (55-gallon) drum
(*pipa*, s.; *mapipa*, pl.), one of the most versatile and sought-after commodities,
for instance, morphs into mufflers, barbeque grills, and footlockers, among
other things (fig. 3.6).

The use of scraps to create handmade things invariably conjures the notion
of "recycling." When this vernacular process transcends cultural and spatial
borders, it becomes what folklorist Suzanne Seriff terms "intercultural." She
defines "intercultural recycling" as "the act of recovering and transforming
the detritus of the industrial age into handmade objects of renewed meaning,
utility, devotion, and sometimes arresting beauty" (Seriff 1996, 10). According
to Seriff's framework, the *mafundi* engage in "intercultural recycling" as they
rethink and reshape the jettisoned stuff of the multinationals—Goodyear,
British Petroleum, and Toyota, for instance. Certainly, many *mafundi* working
in the Dar es Salaam Small Industries Cooperative Society (*Ushirika wa
viwanda vidogovidogo*; known as DASICO) conceptualize that they turn objects
that once served one function into something different. One *fundi chuma*
described the process as *"malighafi inayofanya kazi nyingine"*—materials
that do another work. Another *fundi chuma* indicated, *"Hakuna kitu cha
kutupa; kila kitu ni mali"*—there is not a thing to throw away; every thing is
wealth. That "every thing is wealth" for this *fundi* challenges conceptions of
his materials as being "waste." "Recycling," as people in the West most often
consider it, however, is not in the lexicon of the *mafundi*. Instead, they use
the words *mabaki* (remnants, remainders) and *skrapa* (scraps) to refer to the
materials that form the foundation of their trade. Although one may argue
that their work constitutes an act of conservation, the *mafundi* rarely, if ever,
regard what they do to be an environmental action.

The intelligent and imaginative use of available resources is standard
operating procedure for *mafundi* living in *bongoland*.[7] Their approach arises

3.5 *Fundi chuma* Ibrahim Saidi Ngalipa and the sign he created for a customer who owns a hardware store in the Kariakoo area of Dar es Salaam. Ngalipa's coworker Mohamedi Athumani Mbombwe once remarked that the sign was a work of art (*sanaa*). Photograph by R. Mark Livengood, DASICO, July 1997.

3.6 A watering can, grill, charcoal stoves, and footlockers, all made from scrap metal, for sale in DASICO. Photograph by R. Mark Livengood, October 1997.

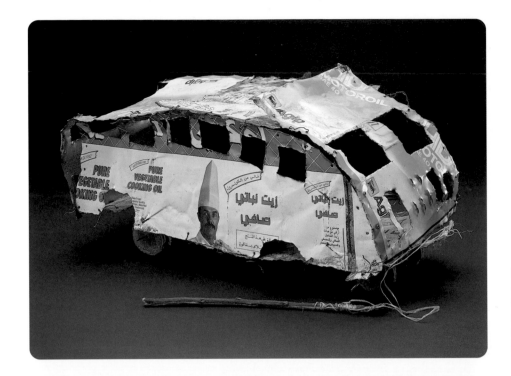

3.7 Pull-toy bus (*basi*), made by Ramadhani Bakari with materials collected from near his home. Ubungo area, Dar es Salaam, 1997. Metal, rubber, wood, and plastic. Length 41 cm. FMCH X97.53.29.

3.8 Soccer ball (*mpira wa kienyeji*) by Mshamu Mayosa. Kijitonyama area, Dar es Salaam, 1997. Plastic bags and twine. Diameter 16.5 cm. FMCH X97.53.27.

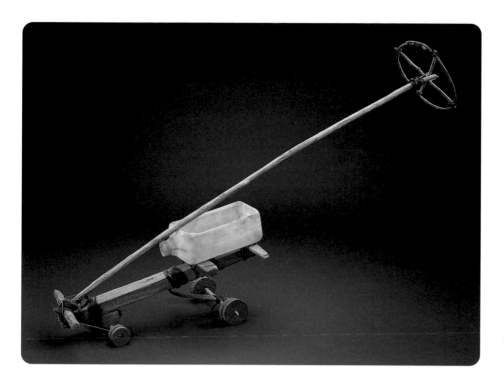

3.9 This toy truck (*gari la mbao*) was made by Athumani Mohamed, who said that he used it to carry things he collected to make new toys. The toy is "driven," and a suspension system accommodates heavy loads. Ubungo area, Dar es Salaam, 1997. Wood, plastic, metal, and rubber. Length 39.5 cm. FMCH X97.53.65a–d.

primarily out of economic necessity, not choice. Who would not want and deserve a sleek new set of Teflon-coated, factory-made pots and pans instead of those that are painstakingly hammered out of scrap 200-liter barrels that once contained caustic chemicals or 10W-30? A similar question seemed to linger in the mind of *fundi chuma* Ibrahim Saidi Ngalipa, who remarked about several objects purchased for the Fowler Museum of Cultural History at UCLA: "We feel resentment. We scorn things like these, but you say it is culture."[8] Thinking in a global context, comparing the methods he uses and the objects he makes to what he sees in newspapers and on television, Ngalipa wonders what could be significant enough about the work he and his friends must do so as to engender outside interest (fig. 3.5). Indeed, several *mafundi*, without a shred of irony, referred to their trade as "*kazi ya njaa*"—the work of hunger. Such comments ask one to consider seriously the gravity of local realities and reflect critically on the vast economic disparities between parts of this contiguous world, differences of which the *mafundi* are keenly aware.[9]

To endeavor to understand the work of the *mafundi* means listening to and closely observing men thinking and working. My fundmental challenge in this essay is to develop a representation that emphasizes the ideas of *mafundi* and introduces basic "local categories and definitions" (Hardin and Arnoldi 1996, 3).[10] Assembling selections of the verbal and visual information that I documented in the field into an arrangement, I build a broad context of the *mafundi* and what they create. My focus is on several *mafundi* who work in DASICO, an atelier located in the Gerezani area of Dar es Salaam. One need only get out and get moving, however, to recognize that the use of *mabaki* surfaces in myriad forms on nearly every city street.

3.10 Athumani Mohamed, Jumanne Mohamed, Ramadhani Bakari, and Heri Yohana (left to right) make toy vehicles from scraps they find in the streets of their neighborhood in Dar es Salaam. An old bus sitting behind them, when stripped of its usable metal, is an important source of raw materials. Photograph by R. Mark Livengood, Ubungo area, Dar es Salaam, June 1997.

First, board the Nissan minibus, or *daladala*, at Shekilango Road, outside the New Checkpoint Bar in the Sinza area, bound for Gerezani, located in central Dar es Salaam about forty-five minutes to the southeast. Slide the conductor 150 shillings as the driver, Sweet Menthol (SM) cigarette dangling from his lip, pushes the cassette into the tape deck and eases the *daladala* onto the road. The minibus zooms off, the tinny sound of Zairean *soukous* music trailing out its windows into the sultry morning air.

The street buzzes with commerce and play. Men and women tote fresh fruits and vegetables, sometimes in baskets, sometimes in plastic bags, home from roadside stands. Young boys often twist such bags into soccer balls (*mipira ya kienyeji*) which occasion pick-up games (fig. 3.8). Many children kick, push, or pull toys pieced together from detritus found in the street—scrap oil cans, plastic jugs, blown-out flip flops (figs. 3.7, 3.9). Athumani Mohamed, Jumanne Mohamed, Ramadhani Bakari, and Heri Yohana, for example, search their neighborhood in the Ubungo area for proper materials to shape into a variety of toy vehicles: *pik-ap* (pick-up); *teksi* (taxi); *rova* (Land Rover); and *basi* (bus; fig. 3.10).

At the intersection of Shekilango and Morogoro Roads, the *daladala* swings left toward the city's core. If one turns right, however, and continues for about 110 kilometers, the town of Chalinze eventually comes into view. Chalinze lies at a crossroads, one road leading due west toward Morogoro and Dodoma. The other heads north to Moshi and Arusha, toward Kilimanjaro and the game parks where Hemingway could not step out of his tent without shooting his rifle. Here is a perfect example of traffic on the contemporary Tanzanian highway: long distance container trucks tugging imported goods to Burundi and Rwanda; clunky overland trucks hauling loads of pierced, tattooed travelers toward the beaches; chunky Land Rovers stuffed with aid workers and government officials. This scene inspires several young men to re-create, in detail, the vehicles that stream by them daily (figs. 3.11–3.13, 3.15). At their outlet in the dusty lot of the Five Star Petrol Station, across from the Mekka restaurant, they sell their scrap metal creations primarily to tourists.

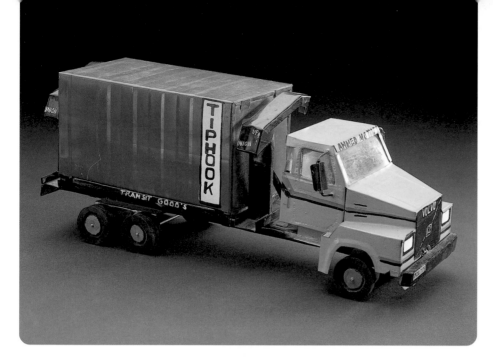

3.11 Container truck. Chalinze, Tanzania, 1997. Metal, paint, rubber, and plastic. Length 32 cm. FMCH X97.53.36.

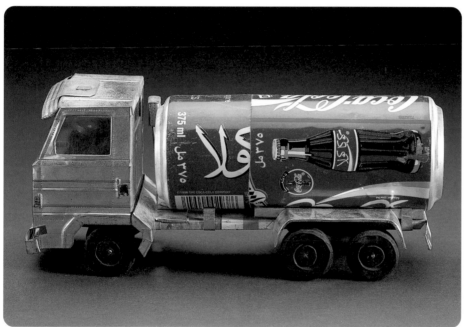

3.12 Tanker truck. Chalinze, Tanzania, 1997. Metal, rubber, and plastic. Length 23.5 cm. FMCH X97.53.39.

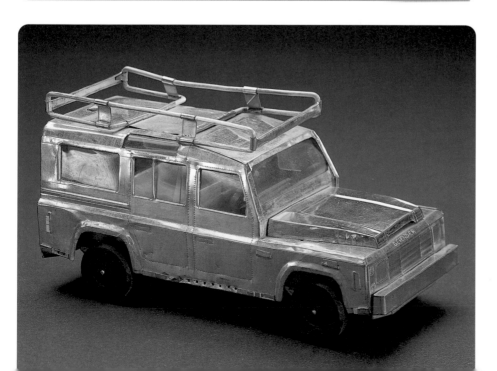

3.13 Land Rover. Chalinze, Tanzania, 1997. Metal, rubber, and plastic. Length 18 cm. FMCH X97.53.37.

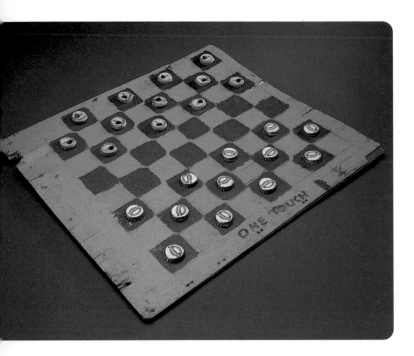

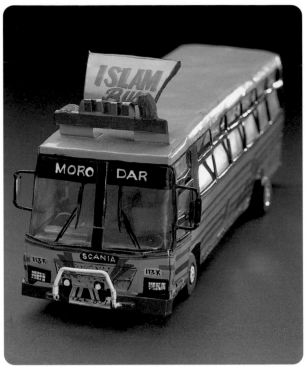

The variety of "toys," as they call them, for sale is considerable; prices are negotiable and barter—for T-shirts and sunglasses, for instance—is acceptable (fig. 3.16). Not surprisingly, the men dispatch some of their work to Dar es Salaam to sell in front of tourist-class hotels (fig. 3.17).

Back in Dar es Salaam, the *daladala* stops frequently. Vendors line the street, sitting on wooden benches, playing *drafti* (checkers), often listening

3.14 Checkers (*drafti*) is one of the games played in the streets of the city. Bottle caps, such as these from Tanzanian beer bottles, are often used as playing pieces. Dar es Salaam, 1997. Wood, paint, and metal. Dimensions of board 43.7 x 48.7 cm. FMCH X97.53.67a–b.

3.15 This toy bus is painted to resemble a popular bus company that covers the route between Morogoro and Dar es Salaam. Chalinze, Tanzania, 1997. Metal and paint. Length 37.8 cm. FMCH X97.53.35.

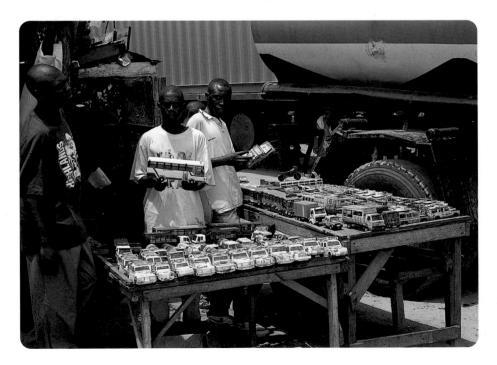

3.16 In the lot of the Five Star Petrol Station in Chalinze, about 110 kilometers west of Dar es Salaam, young men sell "toys," as they call them, primarily to tourists. Such toys are also available at many tourist-class hotels in Dar. Photograph by R. Mark Livengood, Chalinze, Tanzania, October 1997.

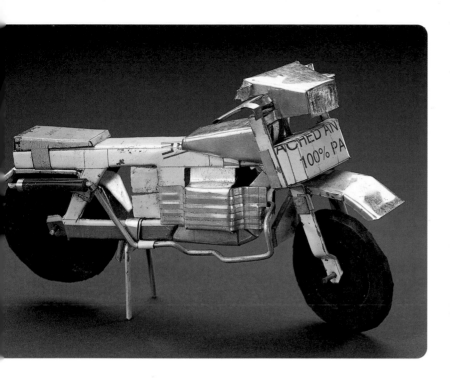

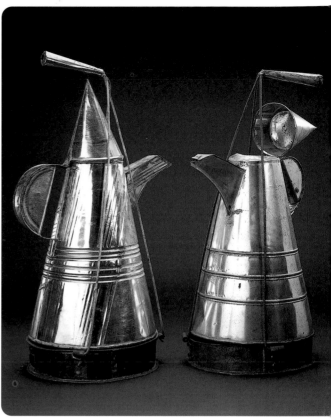

to Radio One (fig. 3.14). The worn wood of benches materializes hours of conversation as the men who shine shoes and sell corn roasted on grills, which are made from scrap metal, gather together to *kupiga stori* (tell stories) and *passtime* (pass the time). They sip freshly roasted coffee poured by a man into small porcelain cups from a conical-shaped pot called a *dele* (*madele*, pl.). Higher-end *dele* were originally, and sometimes are still, made from brass. The *dele* for daily street use is fashioned from discarded tins of cooking oil, shortbread, or ghee, which are most often turned inside out; the printed side prevents rust (fig. 3.18). Such tins are also often used to make the walls of a *kibanda cha biashara*, a small business stall where one can buy hundreds of mass-produced items—bandannas, bubble gum, or cigarettes sold one-by-one (fig. 3.19).[11]

Next, step out of the *daladala* onto Msimbazi Street at Mafia Street in Kariakoo, the major market district of the city. Walk south toward Gerezani. Kariakoo spreads into Gerezani where Msimbazi Street intersects with Uhuru Street. Near the roundabout, tucked into a side street behind the Sportsman cigarette cart, a *fundi viatu* is open for business. His shop sits on a heap of rubber scraps and worn tires; a tarp strung across the top wards off the equatorial sun. He uses razor-sharp knives to turn old tires that he purchases into a variety of sizes and styles of footwear. One style, *kimaasai*, is used by the Maasai who live primarily in north-central Tanzania. The extra width of this style's sole helps protect the feet from prickly brush while herders graze their stock. In fact, the sandal's distinctive form reflects Maasai conceptions of what is proper.[12] The chunky sole of another style, the *nzito* (heavy), better suits the city's terrain and is favored by itinerant street vendors (*wamachinga*) who

3.17 This motorcycle was purchased near a tourist-class hotel in Dar es Salaam, 1997. Metal and rubber. Length 18.3 cm. FMCH X97.53.40.

3.18 Coffeepots (*madele ya kahawa*) such as these, made for daily use in the streets, are most often constructed from scrap cooking-oil tins or the remnants of metal used to case batteries. The printing is turned to the inside. Creased lines in the *madele*, like those found in other objects, are an aesthetic convention. Many *mafundi* take artistic freedom with the number of lines and the spacing between the lines and, therefore, develop signature styles. The *dele* on the left was made by Amida Hassan, DASICO, 1997. Metal. Height 54 cm. FMCH X97.53.8a–b. The *dele* on the right was made by an unknown *fundi*, DASICO, 1997. Metal. Height 51.2 cm. FMCH X97.53.7a–b.

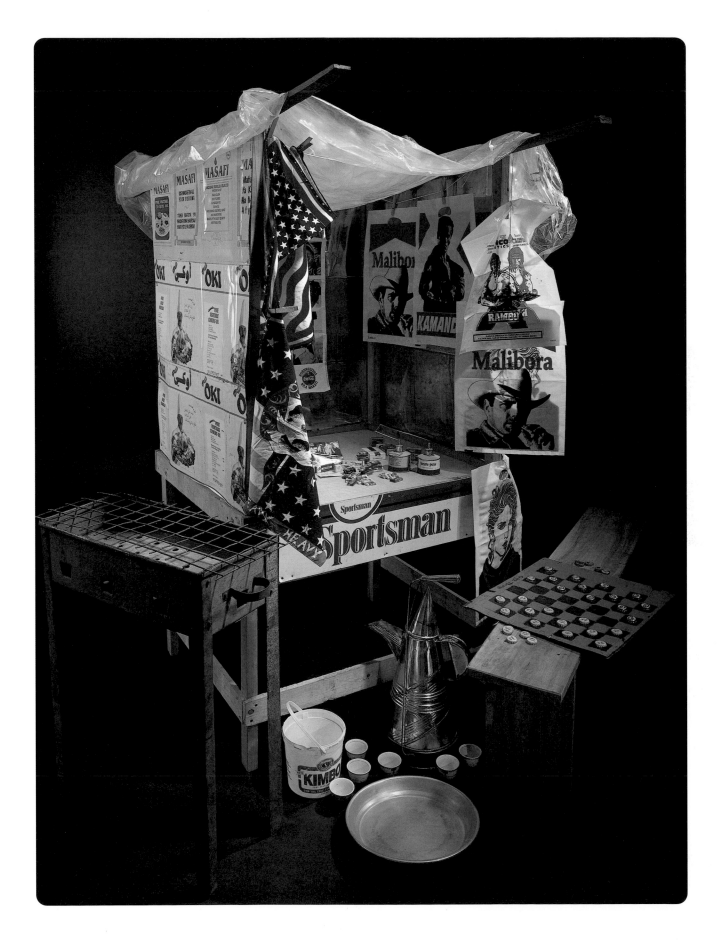

sell many items, including bootleg audio cassettes, used clothes (*mitumba*) imported from the United States and Europe, and caps (fig. 3.20).

At Mbaruku Street, a black sign painted with white letters points the way. Turn left and leave the asphalt; the road is now pitted dirt. The sooty smell of grilling meat rises from Manhunter Park, a restaurant and beer joint that screens movies or sports on the house VCR every afternoon—features on consecutive days include a drama about the Holocaust and a rerun of the infamous Mike Tyson–Evander Holyfield boxing match. Across the street, three men have flopped the engine of a sedan onto the sidewalk and are steadily working. Acetylene torches hiss. Hammers clang. About one-tenth of a mile east of Msimbazi Street, in the heart of Gerezani, swing the red gates of the Dar es Salaam Small Industry Cooperative Society (known as DASICO).

Part street scene, part workshop, part market, DASICO is the material epicenter of the city, and perhaps the country (fig. 3.21). Within the two-block area of DASICO, which is surrounded by a high wall, roughly eight hundred to one thousand *mafundi* work from 7 a.m. to 6 p.m., usually seven days a week. They create a dazzling spectrum of objects, some made with new materials, most made from scraps. It is possible for a person to buy new or have repaired nearly any useful thing he or she may want: furniture, doors, window frames, mufflers, footlockers, keys, seat covers, chicken feeders, charcoal stoves, grills, kerosene lamps, pots and pans, musical instruments, buckets, kitchen utensils, watering cans, water heaters, and front quarter panels for Land Rovers (figs. 3.22–3.26). Customers select from existing stocks of standard objects, such as the balance pans (*sahani za mizani*) or ginger teapots (*madele ya tangawizi*)

3.19 Opposite, It is 6:00 p.m. on Friday, *saa kumi na mbili jioni*. A group of men is gathered around the *kibanda cha biashara*, or small business stall. The sounds of Radio One, "Tanzania's great radio station," fill the air. Patsy Cline is singing about how she is going to fall to pieces. The twangy sounds of slide guitar dissolve into an advertisement for Fanta (Coca-Cola) soda, in which a man, affecting a Jamaican accent, says "Welcome to the world. Fanta, welcome to the world." Next to the *kibanda*, looking up from his game of checkers (*drafti*), a man says "*Sisi tupo*" (We are here). The *kibanda* is an omnipresent and important aspect of the cultural streetscape in Dar es Salaam. Here one can purchase a wide variety of necessary everyday items and catch up on breaking news. The bench (*fomu ya kukalia*) and the frame of the *kibanda* were made by Ramadhani Mohamedi Magema, DASICO, 1997. Bench: wood; frame: metal. Height (bench) 41 cm; height (frame) 179 cm. FMCH X97.536a–e; FMCH X97.53.1d–u. Semeni Shomari S. Mkwama made the *kibanda* walls (*ukuta*), DASICO, 1997. Metal. Height 179 cm. FMCH X97.53.1a–c. The grill (*jiko*), used to roast corn (*mahindi*) or skewered meat (*mishkaki*), was made by an unknown *fundi*, DASICO, 1997. Metal. Height 76 cm. FMCH X97.53.3a–b.

3.20 Three styles of sandals: *kimaasai* (Maasai), *nzito* (heavy), and *mtoto* (child). Gerezani area, Dar es Salaam, 1997. Rubber and nails. FMCH X97.53.20a–b (length 29.5 cm); FMCH X97.53.21a–b (length 26.7 cm); and FMCH X97.53.25a–b (length 17.5 cm).

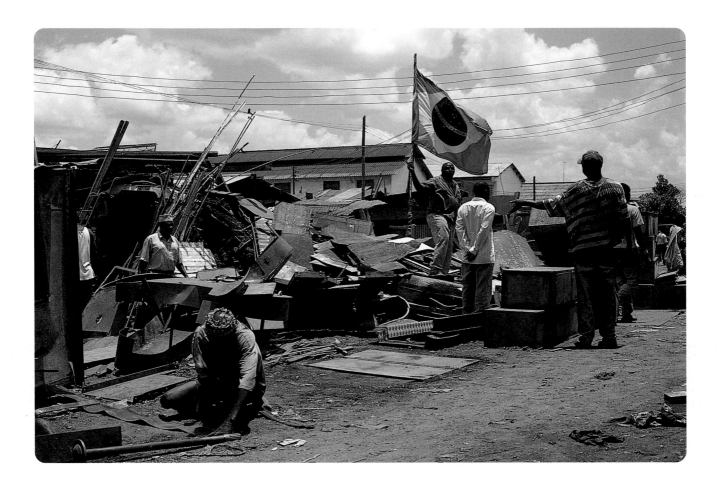

made by Mohamedi Athumani Mbombwe (fig. 3.27), or they commission unique objects, like the sign that Ibrahim Saidi Ngalipa crafted from jettisoned oil barrels for a nearby hardware shop (see fig. 3.5). If a requested item does not exist, a *fundi* will figure out a way to make it; one *fundi chuma* joked that the *mafundi* of DASICO can make anything except an airplane engine.

The men working in DASICO are ethnically diverse and are primarily Muslim or Christian. Most *mafundi* suggest that the greatest percentage of men come from the coastal and southern regions of the country and represent several ethnic groups: Matumbi, Zaramo, Ndengeleko, and Makonde. This heterogeneity does not go unnoticed by many *mafundi*, who consider their working side-by-side in DASICO to be a source of pride. Women are also present in DASICO, although they are not *mafundi*. They purchase objects, but more often they sell fruit or gather wood to stoke the fires on which they cook sticky rice or stiff porridge (*ugali*) and beans, or boil sweet tea thickened with milk (*chai*), at nearby stalls called *mama ntilie*.

DASICO operates as a cooperative, or *chama*, as the *mafundi* call it. To become a member of the cooperative, a man is sponsored by someone who already belongs to the *chama* and accepts responsibility for the applicant. Ideally, a man applies when his mentor deems that he has acquired the requisite skills to practice his trade independently. If accepted, the applicant pays a onetime sum that includes an entrance fee and lifetime dues. He eventually

3.21 Part street scene, part workshop, part market, DASICO is the material epicenter of the city. The Brazilian flag indicates that it is match day for the Chuma Football Club, a soccer team sponsored by the *mafundi chuma* who work in DASICO. Photograph by R. Mark Livengood, October 1997.

3.22 Charcoal stove (*jiko*) and stand by Salum Ally Nkuyu, DASICO, 1997. Wok (*karai*) by Saidi Abdallah Nonga, DASICO, 1997. Spoon (*jalo*) by Mohamedi Limamu using metal from a scrap refrigerator, DASICO, 1997. French fries (*chipsi*), cooked with utensils like these, are a popular food in Dar es Salaam. Metal. Total height 68 cm. FMCH X97.53.5a–d.

3.23 Open-wick kerosene lamps (*makoroboi, vibatari*) by Mzee Kibasila, DASICO, 1997. Metal. Height 10 cm. FMCH X97.53.52.

3.24 Dust pan (*kizoleo cha takataka*) by Semeni Shomari S. Mkwama, DASICO, 1997. Metal. Length 30.5 cm. FMCH X97.53.17.

3.25 Water scoop (*kata*) by Semeni Shomari S. Mkwama, DASICO, 1997. Such scoops are commonly used for washing. Metal. Length 57.2 cm. FMCH X97.53.11.

3.26 Tambourine (*dufu*) by Mohamedi Limamu, DASICO, 1997. Metal. Diameter 20.8 cm. FMCH X97.53.18.

3.27 Ginger teapot (*dele la tangawizi*) by Mohamedi Athumani Mbombwe, DASICO, 1997. The plastic cups and saucers, purchased in Kariakoo, were mass-produced and imported from Kenya. Ginger tea (*tangawizi*), like coffee (*kahawa*), is sold in the streets by itinerant vendors who also sell sweets to complement the beverages. Metal. Height of teapot 55.5 cm. FMCH X97.53.9a–o.

3.33 By request of a client, *fundi chuma* Semeni Shomari S. Mkwama made these two coffeepots (*madele ya kahawa*) from brass, a material difficult to obtain. These *madele* are for display purposes. The three lines creased into the metal are a decorative convention referred to as *urembo* by most *mafundi*. Photograph by R. Mark Livengood, DASICO, October 1997.

that distinguish men who are thought to possess noteworthy skills. One *fundi chuma* suggested that the person who has *akili sana* (great intelligence) is called a *mbunifu* (*wabunifu*, pl.). *Ubunifu* means imagination, and a *mbunifu* is an inventor, an originator (Johnson 1992 [1939], 41). The *mafundi* use the term to describe a man who creates forms distinguishable from the hundreds of standard objects made because of their singularity and the complexity of problem solving involved in their creation. For example, Ngalipa has been identified as a *mbunifu*. Faced with a customer's challenge to produce a sign for a hardware store, Ngalipa created for the first time a sign that resembles a large nut and bolt (fig. 3.5). He has subsequently produced several similar signs, including one that resembles a fan belt and another that looks like an oil can. According to Ngalipa, he would rather undertake projects that require him to devise novel forms than make standard objects. In so doing, he exercises his mind and also gains a reputation of being particularly skilled. Indeed,

Ngalipa's ability distinguishes him from other *mafundi*, especially in the minds
of potential customers; accordingly, additional work comes his way.

The other designation for *akili* is *mjanja*, or trickster. Applied to a *fundi*,
mjanja is not pejorative but rather a positive identification of a skilled craftsman.
The clever *mjanja* resonates with the devious *bricoleur*. Although the *mjanja*
may not generate completely novel forms, often copying from existing models,
his talent distinguishes him in the eyes of others as he makes objects of relative
complexity. Juma Maulidi Mbande, for instance, has been called an *mjanja*
because of his talent for making a particular item.

Juma is most often found working outside under a canopy constructed
of corrugated steel and the bed frame of a pick-up truck. Not yet thirty, Juma
came to DASICO from Kibaha, the major town between Dar and Chalinze.
Like most *mafundi* who have mastered basic skills, he can make a number of
standard objects: charcoal stoves, coffeepots, and buckets. He is best known
for his specialty, however, which is making grills for automobiles and trucks,
or *sho ya gari*.

When Juma creates *sho* for a Land Rover 110, he first negotiates a price
with the customer, as is common in DASICO. Normally, a *fundi* quotes an inital
figure and then he and the client bargain until they reach an agreement. For
custom, commissioned work, the client pays an advance, usually half of the
final price, with the balance due on the project's completion. In determining
a price for an object, the *fundi* takes into account his assumptions about how
much a customer is able and willing to pay. He bases these assumptions, in part,
on his assessment of the clothing and speech of the customer. Most often,
mafundi figure costs based on the price of materials and the length of time
they estimate spending on a project; they are not paid by the hour. A relatively
complex project like making *sho* fetches a higher price than a straightforward
undertaking such as making a bucket. Indeed, like Ngalipa, one reason Juma
prefers to make *sho* is because he reaps greater financial benefits from his ability
to create a distinctive object. He explains that with such an item *"unaweza
kupata soko"*—you are able to get a market.

Juma begins making the Land Rover 110 *sho* by examining the grill of
an existing vehicle. Sometimes customers bring him fragments and he must
conceptualize how he will make a new, complete grill based on what he is
given. He sketches the grill and jots down its measurements on the back of a
cigarette pack, which he consults frequently when he begins to cut and hammer
metal. For this project, Juma uses twenty-four gauge, galvanized scrap metal
(*bati*). He bought the material from another *fundi* who sliced a piece from a
box that turned out to be too large for a customer's specifications.

The *mafundi* use the term *sho*, perhaps derived from the English word
show, to describe objects, or characteristics of objects, that they perceive to
be decorative. For example, one *fundi* called a curving concrete baluster *sho*.
Another used the term to describe the chrome on a motorcycle. A related
Kiswahili term is *urembo*, or ornamentation. As one *fundi* described it, *urembo*
causes pleasure (*kupendezesha*), and similar to *sho*, it is part of the aesthetic
vocabularly of the *mafundi*. Carpenter Ramadhani Mohamedi Magema, for

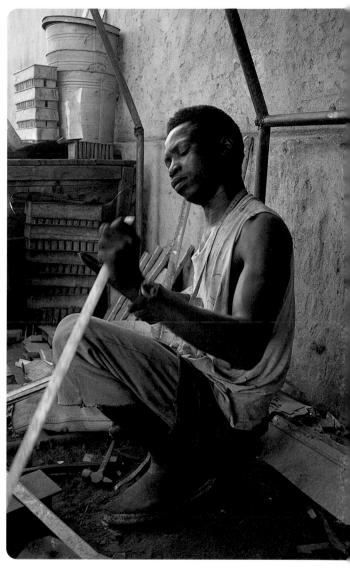

instance, indicated that the V-shaped notches on the legs of the benches he makes are *urembo* (fig. 3.34). Semeni once communicated his evaluations of the wall of the *kibanda* he was making from old cooking-oil tins, with their various languages and colorful pictures of plentiful meals: "It pleases. First, there is the color. And these pictures which are there are pleasing. It is not possible to buy new *bati* to put on a *kibanda* like this. It does not please. Therefore, we bought this *debe* to get *urembo, urembo*"[15] (see fig. 3.19).

Many metalsmiths describe the lines they crease into the various objects they make—coffee and teapots, chicken feeders, and buckets—as *urembo*. Within the conceptual scheme of many *mafundi chuma*, such lines constitute an aesthetic convention. Most often, the lines appear in evenly spaced threes, such as in the brass *madele* Semeni made. Many *mafundi*, however, play with the number of the lines and spacing between lines, and, therefore, develop signature styles (see fig. 3.18). Juma once suggested that every *fundi chuma* is different and does what he feels is pleasing when applying these lines.

3.34 *Fundi seremala* (carpenter) Ramadhani Mohamedi Magema and the bench he made for the Fowler Museum of Cultural History. Such benches are ubiquitous on the streets of Dar es Salaam. This bench is made from a wood called *mninga*, although others are assembled from scraps. Photograph by R. Mark Livengood, DASICO, October 1997.

3.35 *Fundi chuma* Juma Maulidi Mbande checking the squareness of a slat for the Land Rover 110 grill (*sho ya gari*) he made. Judgments about form are not always articulated verbally, but can also be revealed by gesture. Photograph by R. Mark Livengood, DASICO, September 1997.

The formal judgments of the *mafundi* also address an object's utility. The men often use the terms *imara* (strength) and *stili* (steel) to refer in a positive way to an object built to last. Such an object results when the "technical treatment" of a *fundi* achieves a "certain standard of excellence" (Boas 1955 [1927], 9–10). Joints and seams are solid. Corners are square. Soldering is even and firm. In contrast to *imara*, the *mafundi* use the negative evaluation *bovu* (bad, unsound) to refer to slipshod work. Certainly, in making the Land Rover 110 *sho*, Juma works toward technical excellence and *imara*. He carefully measures the spacing between the slats of the grill. He tests the bonds of the soldering. He pauses frequently to check the squareness of his emerging creation. Most often, Juma does not verbally articulate his judgments of form. Instead, he suggests them in gestures—a glance of the eye, a nod of the head (fig. 3.35).

That making objects is a process becomes clear when one observes Juma creating the *sho ya gari*. Rarely, if ever, does a *fundi* completely fabricate an item from beginning to end in a single, steady action. Interruptions and breaks—to talk with friends and customers, to eat and drink, to peruse products sold by the itinerant vendors—are aspects of the process. In this manner, the making of an object is an event that involves not only the production of things but also other expressive genres: gesturing, eating, and joking, to name a few.[16] Moreover, sitting closely and watching Juma leads one to the realization that this is only one of hundreds, perhaps thousands, of such events taking place in DASICO each day; elsewhere within the cooperative's walls other men are pursuing their own such projects.

"Can you imagine how many hammers you can hear at one time?" Celestine Simama asks, referring to sonic waves washing over Kisarawe Street. He pays close attention to how the world sounds, for in addition to being a soldier and secondary school teacher, he composes and plays music, specifically steel band. Simama is also a *fundi* who makes the instruments, or pans—bass pan and guitar pan, among others—he uses to play steel band music. On this day, he has been hammering the remains of a 200-liter, eighteen-gauge, bright green British Petroleum oil barrel into the double tenor steel pan commissioned for the Fowler Museum (fig. 3.36).

Simama grew up in a musical family near the town of Musoma in western Tanzania. Like his parents and his brother, he was a choir singer. A collector of traditional Tanzanian musical instruments and a fan of American jazz, Simama once won second place in a national competition for an original musical composition. When he entered the Tanzanian National Service in the early 1980s, his superiors, aware of his musical interests and talents, sent him to the West Indies to participate in an exchange program. He spent a total of three years between 1984 and 1988 in the Caribbean, mostly in Georgetown, Guyana, studying how to compose and arrange steel band music, as well as how to craft pans. He then returned to Dar es Salaam, an active bearer of what he refers to as an "imported" tradition.[17]

Simama presently directs two steel bands in Dar es Salaam: the first is comprised of thirty-eight National Service personnel, who primarily play for official state functions. The other is his private band, the Pan Percussion

3.36 Celestine Simama made these double tenor steel pans in June through August 1997, Dar es Salaam. He makes all of the steel pans for his band, the Pan Percussion Orchestra (PPO). Metal. Height of drum stand 98.2 cm. FMCH X97.53.2a–c.

Orchestra (PPO), for which Simama recruits young men from his neighborhood. Simama calls the PPO his "street band," because its sixteen musicians, he says, are "street boys." Concerned about his community, Simama believes that the PPO serves as a positive social function for young men who may otherwise be idle. "Music is good," according to Simama. "It makes *vijana* (youth) to have something, to unite people." The PPO performs mostly for expatriate audiences because finding a local audience is difficult, says Simama, due to popular conceptions that steel band music is too "foreign," too far removed from a meaningful cultural context. Simama finds this attitude perplexing, because he believes that a dynamic syncretism of traditions is a reality in contemporary Tanzania. He suggests:

> Everything comes from different parts of the world. If you say it's
> a foreign culture, we don't want to improvise…. Things are changing
> you know. We have Arabian people here. Europeans who will be here
> in Tanzania as Tanzanians. And Indian people. So if you say you want
> Tanzanian culture, you will fail to get the real Tanzanian culture if
> you try. I feel we can say imported culture, but not foreign culture
> [because there are] so many cultures [in this] society.[18]

The repertoire of the PPO reflects Simama's thinking. The band plays a variety of tunes ranging from Simama's original, prize-winning composition to East African popular music to John Denver songs to Caribbean steel band standards.

Simama makes all of the pans for both bands. According to him, "pan technology"—the creation of pans—entails six distinct steps, or "processes,"

which he labels "sinking," "grooving," "plastering," punching-up," "burning," and "tuning."[19] The first process involves hammering the bottom of the barrel (using a chunk of automobile axle in this case) in order to sink it to the requisite depth—eight inches for a double tenor steel pan. During sinking, care must be taken to avoid splitting the metal, and thus ruining the pan. After the pan is sunk, Simama uses a ruler to carefully measure the sections, or "dents," which he will ultimately tune into notes; the musician strikes these areas when he plays. Simama then uses a hammer and a center punch to groove, or outline, the dents. Plastering entails hammering around the dents in order to make them more pronounced and to further thin the metal. Using a hammer, blocks of wood, and sometimes corncobs, Simama then punches-up the dents from the back side of the pan, creating pillows of metal that will be the notes. Next, he tempers the pan over a wood fire. Finally, he tunes the pan using a hammer in one hand to knock on or around a dent while tapping it with a mallet in the other hand, continuously sampling the evolving pitch. He tunes first by ear and then with an electronic tuning device given to him by a German friend. Completing a pan can take months, for Simama must slot the time-consuming and physically demanding work into his regular, busy schedule. In order to complete the pans commissioned for the Fowler Museum on time, he accelerated the process by taking a five-day leave from his duties.

Simama performs the six processes in different parts of the city, burning and tuning near his home in the Mtoni area, next to the political branch office where he rents space to store his pans and practice with the PPO. Open space and the relative absence of noise allow him to burn and tune most effectively in that location. The cacaphony of DASICO, however, is one reason he is comfortable to perform the initial processes in Gerezani, for he can make pans without disturbing his neighbors. "It's very noisy work," says Simama, "so I thought probably it could be nice if I looked for a place that would be suitable for noisy, noisy constructions. It's only Gerezani. I like the place."

Simama often enlists the assistance of other men, all of them well skilled in their own rights, for every process except the last. Tuning requires the trained ear of a musician and the abilities of a metalworker; only Simama has the proper combination of skills. None of the men Simama brings into the making of a pan, however, are present from start to finish for all six processes. Concerns about keeping pan technology a secret, about remaining the primary person in Tanzania able to craft an entire instrument, motivate him not to reveal all of the processes to any one person. The finished object emerges from the closely guided work of many, but Simama deliberately disperses the efforts of these makers; therefore, the pan actually has multiple makers, although Simama remains the primary creator.

For this particular project, Simama has once again hired Saidi Abdallah Nonga, a *fundi chuma* who works in DASICO, to help with sinking and plastering. Saidi specializes in making *karai* (*makarai*, pl.), woklike cooking pans hammered from scrap metal (see fig. 3.22). As part of Saidi's remuneration, Simama gives him the remains of the oil barrel after he cuts away the sunken, nascent pan. When completely flattened, this metal slab yields approximately seven *makarai*,

and the barrel's bottom yields one, for a total of eight, which Saidi can make and sell in a day. The materials flow in this way: Simama uses British Petroleum's scraps to make a steel pan; Saidi uses the scraps of Simama's scraps of British Petroleum's scraps to make *makarai*; Juma Maulidi Mbande uses the scraps of Saidi's scraps of Simama's scraps of British Petroleum's scraps to make a gauge (*geji ya kienyeji*) to measure parts for his *sho ya gari*. When the bits and pieces finally become too small to make anything useful, the men load them on a truck that takes them to a man just outside of DASICO who weighs them, paying by the kilo, with the intent of selling them to an industrial salvage operation. Even the residual oil that seeps from the barrel while Saidi sinks it is scooped up in cups by other *mafundi*, who use it to lubricate nuts and bolts.

The form of the *karai* is similar to that of a steel pan. Making the bowl-like *karai* and the steel pan entail the careful thinning and shaping of eighteen-gauge metal. Saidi excels at the technique because he is able to sink without splitting the metal as it becomes thinner. Saidi's considerable skill is one reason Simama has hired him. The other is his dedication to completing these physically demanding processes. In the past, Simama has encountered conflict with some *mafundi* in DASICO, having paid in advance for work never completed. Saidi and Simama have worked together previously, however, and Saidi considers making pan *"kazi maalum"* (special work) from which he gains *"ujuzi"* (knowledge). Saidi's respect for Simama is evident in the way he addresses him as *mwalimu* (teacher; fig. 3.37).

Saidi is not the only *fundi* working in DASICO with considerable admiration for Simama. Many *mafundi*, carpenters and metalsmiths alike, refer to Simama as *mtaalam* (*wataalaam*, pl.) a designation that complements the idea of the *fundi*. Related to the noun *elimu* (knowledge, learning), a *mtaalam* is defined as an "educated, learned, well-informed person" (Johnson 1992 [1939], 82). Simama explains the distinction between *fundi* and *mtalaam*:

> You can be only *fundi*, but not *mtaalam*. For instance, there I met in Guyana people who can make pans, right, but they don't know measurements. They just see because they are experienced how to make those pans. So, those are pan makers. But they won't elaborate how it is. They are not musicians at all; they don't know which is B-flat, which is C, they just know by knowing sounds. But they're *fundi*s because they make their own instruments. But we don't say they are *wataalam* because they don't have this musical knowledge. [The *wataalam*] need to know to identify sounds, to elaborate to people, to compose different kind of melodies and to arrange music from somewhere else. That's what I do. I can arrange music. I can elaborate and know what I am doing.[20]

A *mtaalam* possesses a particular knowledge that comes from considerable study, as in the case of Simama, who spent years in Guyana studying steel band music and pan technology. In contrast to the *fundi*, the *mtaalam* most often learns by formal methods, for example, in school, and has a knowledge

that is not specifically technical or mechanical. An accomplished linguist or historian can also be called *mtaalam*. As this special designation suggests, Simama has a distinctive identity in DASICO: because as a professional soldier he remains somewhat of an outsider to the cooperative's daily happenings; because he speaks English and has an upper-level education; because of his knowledge, which comes from years of specialized study; and because of the considerable skills he displays in making unique objects.

While making pans, Simama makes numerous choices that ultimately affect the pan's form. Because he feels that some people appreciate pans as objects more than as instruments, he applies bright paint in bold stripes to their surfaces in order to attract people to come and listen to the music. Furthermore, in outlining the dents during the process of grooving, he could select to make the dents round or he could make them in a connected bar, as other pan makers elsewhere choose to do. Simama makes the dents square and sets them apart, however, for two reasons. First, he indicates that square, separated dents nicely "frame" the pan, making it look balanced and even. Second, he believes that such dents facilitate aesthetically pleasing performances by the musicians. He prefers synchronized, side-to-side movements of band members, movements that square, separated dents help the musicians achieve. This concern with the pans' influences on motion also informs how Simama places the pans on their stands. Pans must hang at a particular angle, causing the performer to bend at the waist while maintaining his chest open and his head up. Simama indicates that this movement is most interesting for the audience to watch. In this manner, an important aspect of making pans for Simama is imagining how the objects will inspire motion when the pans and their players merge during performances that are simultaneously visual, kinesthetic, and sonic.

Pans are musical instruments and as such they are ultimately about sound. Decent sound is the product of skillfully made and played pans. For Simama, attention to sound is an important dimension involved in the making, not just the playing, of pans. Clearly, his sense of hearing guides the process of tuning. He knocks and taps on the metal until the notes become "very, very light." Sensitivity to sound is also important in the process of sinking. During sinking, if the metal is split by pounding too vigorously or too long in one spot, the drum will probably be ruined and the process must be started over on a new barrel. Such a mistake costs time and money. Because of the effects that the previous contents of the barrel may have on the metal as well as the relative degrees of rust and age, every barrel reacts differently during sinking. By paying close attention to the ringing of the metal as Simama hammers, he is able to sense potential weak spots and adjust his technique accordingly.

Celestine Simama has many roles. In addition to being a soldier and teacher, he is a community musician who creates the possibility for "street boys" to unite and play steel band music. Respected *fundi* and *mtaalam* with a demanding sense of excellence, Simama sums up the art of making steel pans by saying, "It needs courage, it needs will to finish a pan. It's difficult work, but after that we enjoy" (fig. 3.4). As the active bearer of an "imported" tradition, he illustrates that it makes complete sense that he uses the knowledge

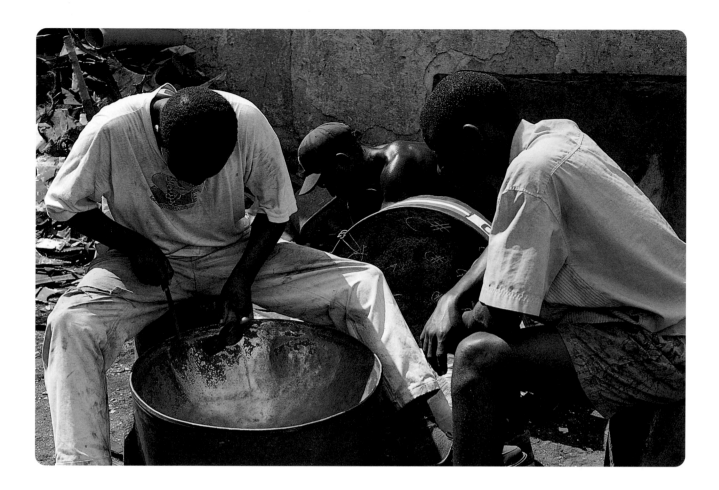

he gathered in Guyana and brought back to Dar es Salaam to make musical instruments from the scraps of British Petroleum, on which he plays American country and East African popular music with his street band at the German Cultural Center. Simama, like other *mafundi*, has seized upon a vibrant mix of raw materials, thoughtfully exerted his skills, and created. ◆

3.37 "It needs courage, it needs will to finish a pan," says Celestine Simama. Here *fundi chuma* Saidi Abdallah Nonga watches Simama plaster the double tenor steel pan commissioned for the Fowler Museum of Cultural History. Photograph by R. Mark Livengood, DASICO, June 1997.

Daddy Grizzle yawned and stretched the way he did every morning, then plumped his pillow and . . .

Z Z Z Z Z Z Z Z Z Z Z Z

fell right back to sleep.

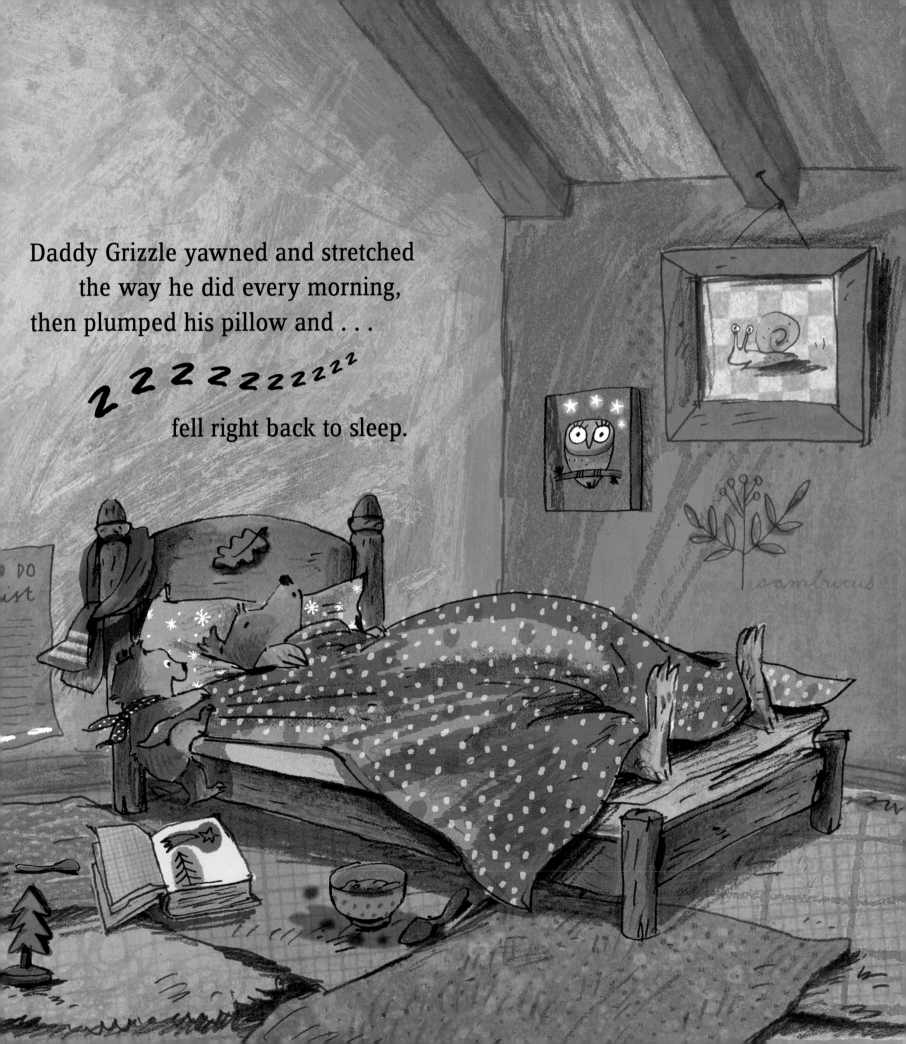

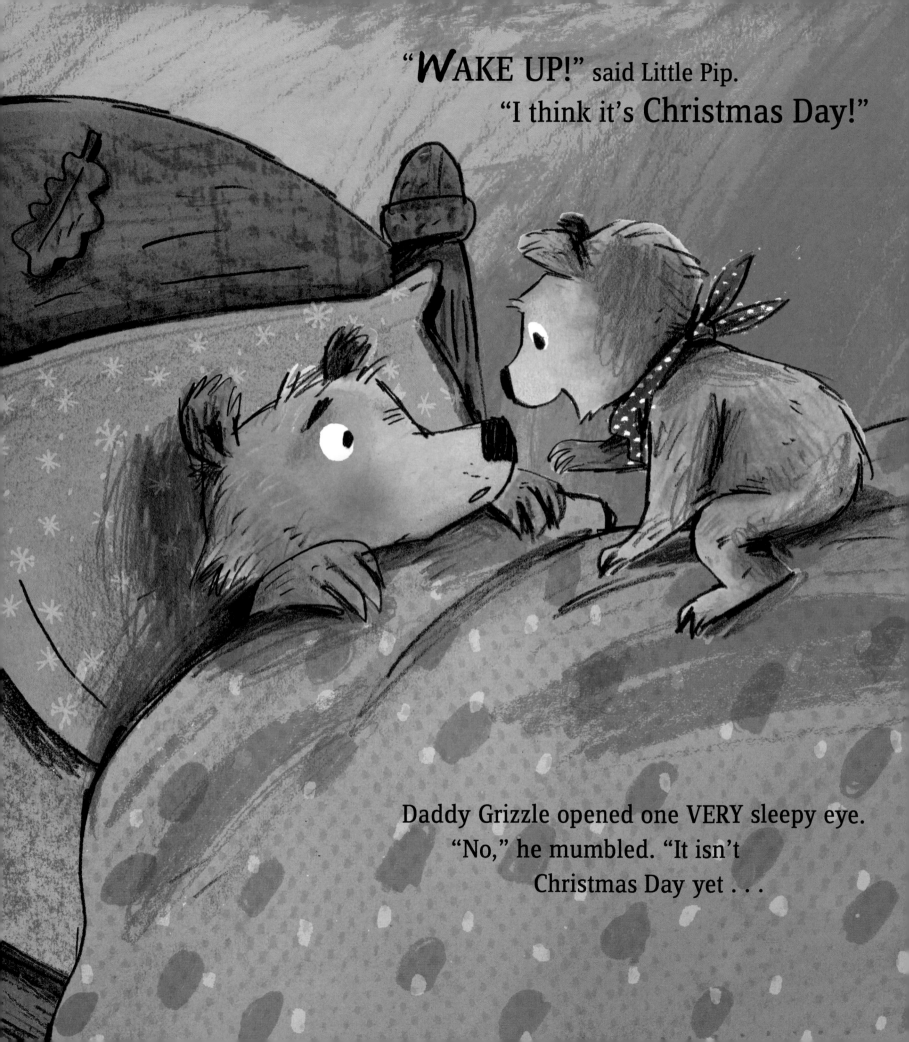

"**W**AKE UP!" said Little Pip.
"I think it's **Christmas Day!**"

Daddy Grizzle opened one VERY sleepy eye.
"No," he mumbled. "It isn't
Christmas Day yet . . .

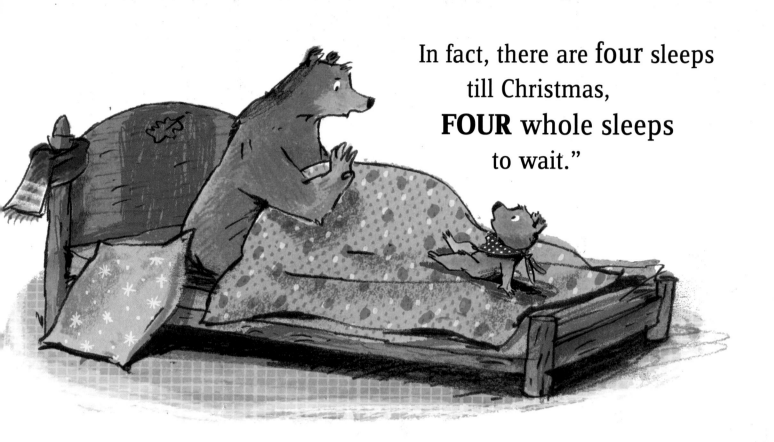

In fact, there are four sleeps
till Christmas,
FOUR whole sleeps
to wait."

Little Pip gave a disappointed sigh.

"But never mind," said Daddy Grizzle.
"After all, we still have PLENTY
of things to keep us busy."

First they needed to find a tree . . .

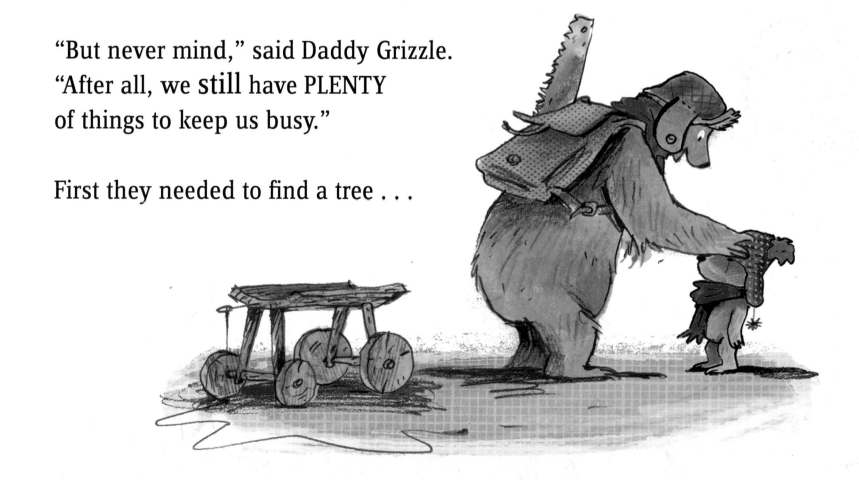

So out they went, Daddy Grizzle and Little Pip,
and searched until they found the perfect tree,
waiting quietly in the frosty woods.

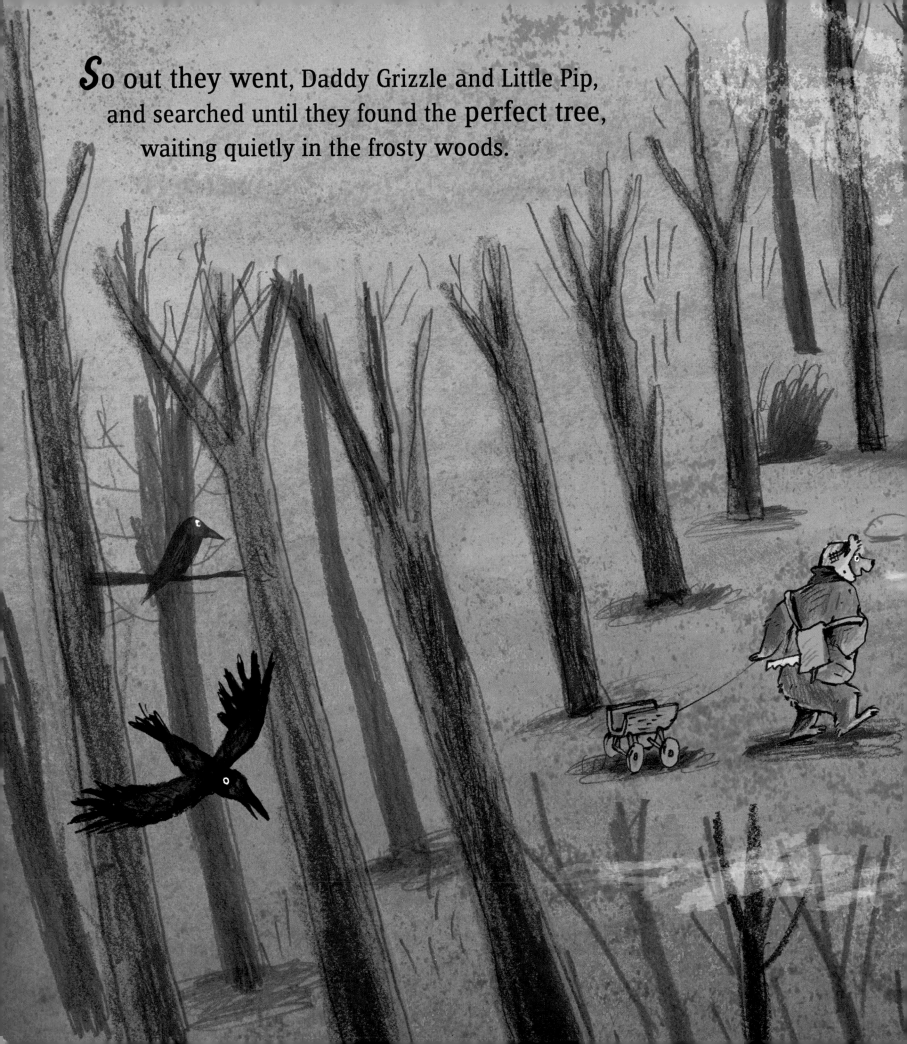

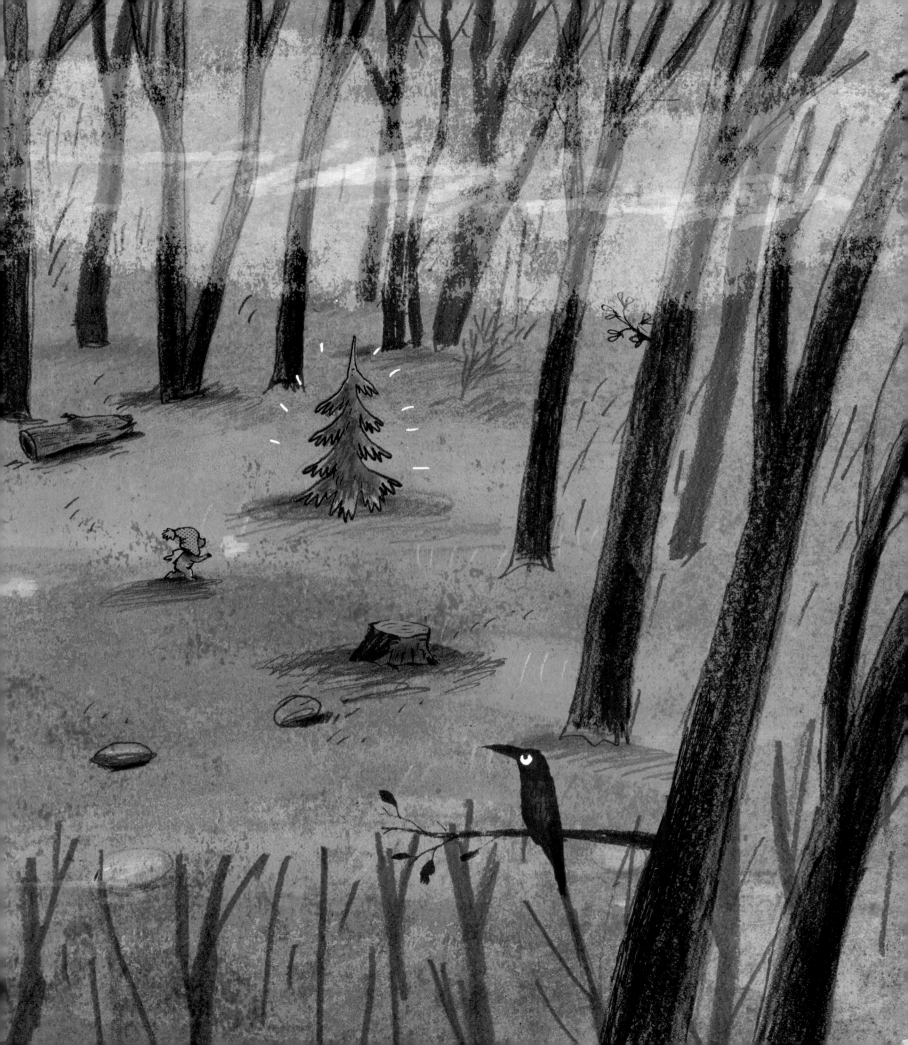

And that night they strung the tree with all sorts
 of lights and loveliness, then cuddled up
in the comfiest of chairs.

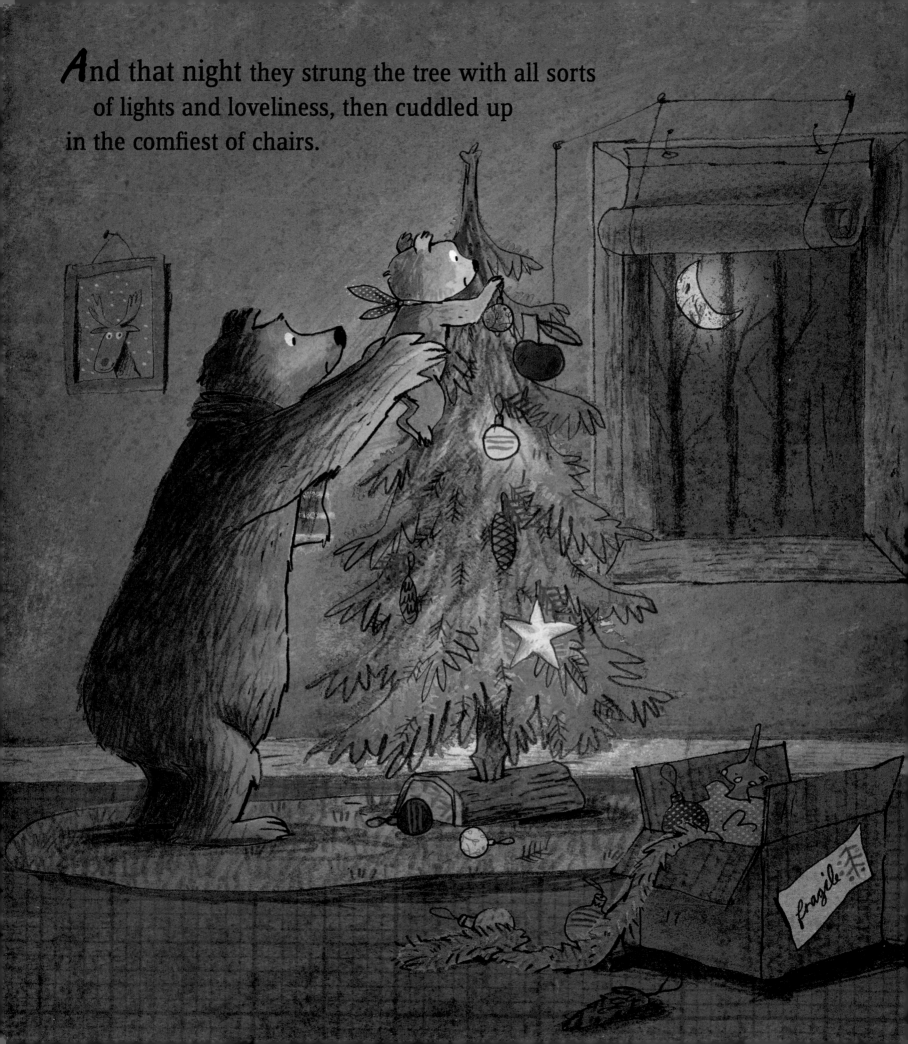

"**FOUR** whole sleeps till Christmas,"
Daddy Grizzle reminded Little Pip.

"OK, Daddy . . ." murmured Little Pip.
"One . . .

two . . .

three . . ."

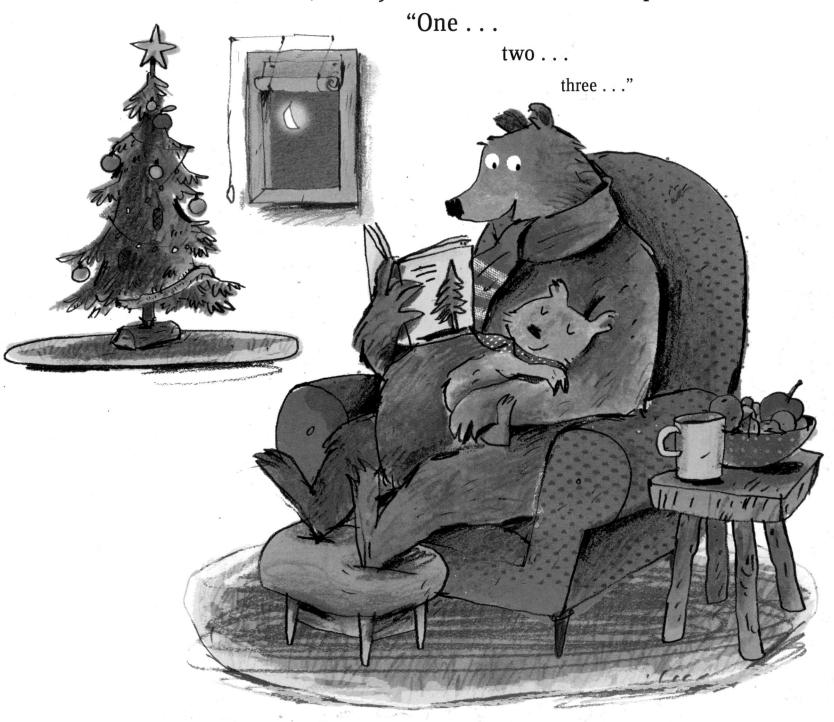

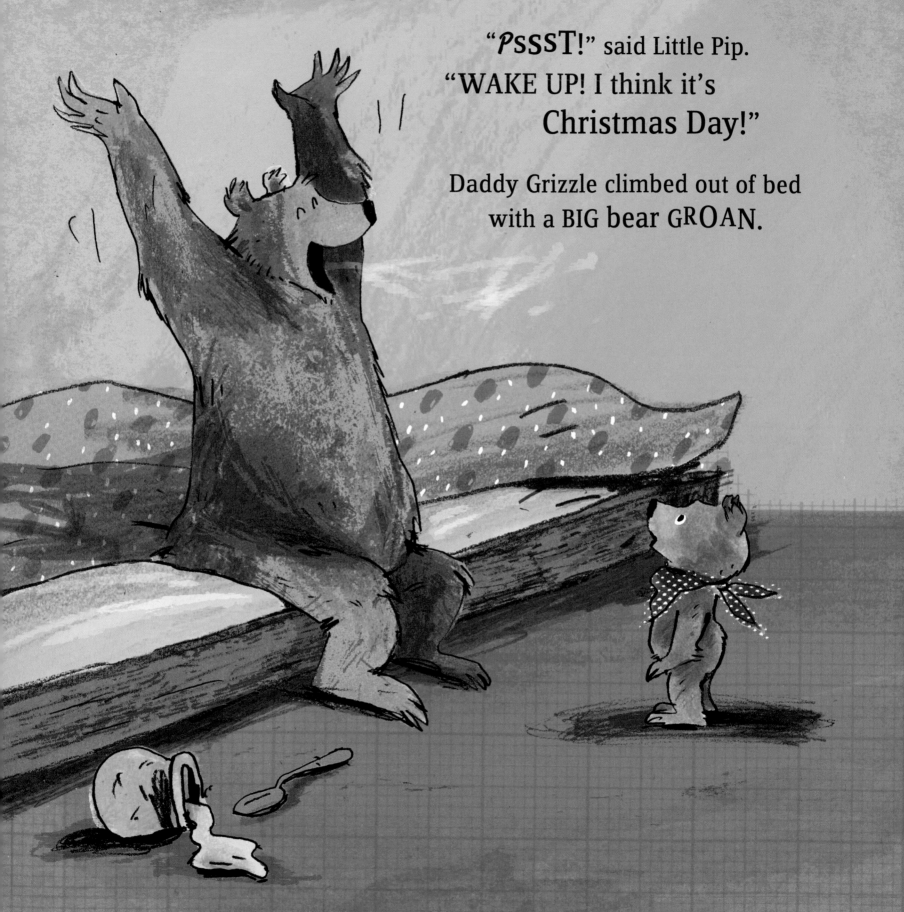

But the next morning a certain someone seemed
to have forgotten something very important . . .

"PSSST!" said Little Pip.
"WAKE UP! I think it's
Christmas Day!"

Daddy Grizzle climbed out of bed
with a BIG bear GROAN.

"No," said Daddy Grizzle,
 "it isn't Christmas Day yet.
There are three sleeps till Christmas,
 THREE whole sleeps to wait."

"Three . . ." sighed
Little Pip. "Three . . ."

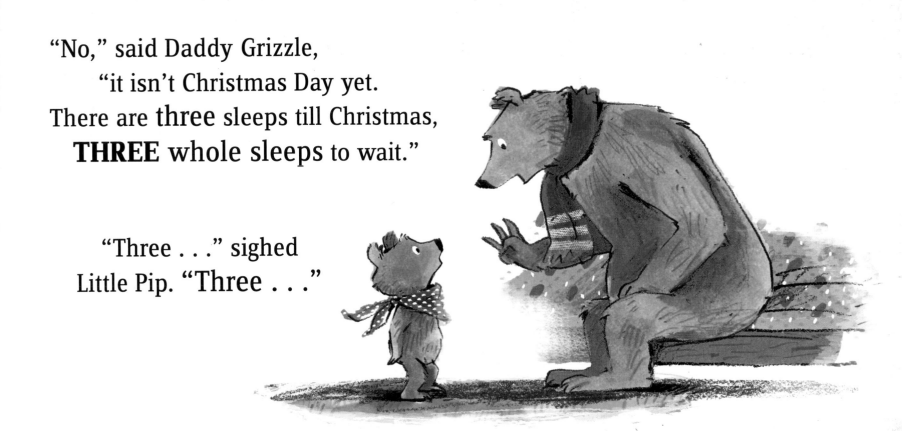

But perhaps that was just as well.
 After all, they hadn't sent a single
 season's greeting.

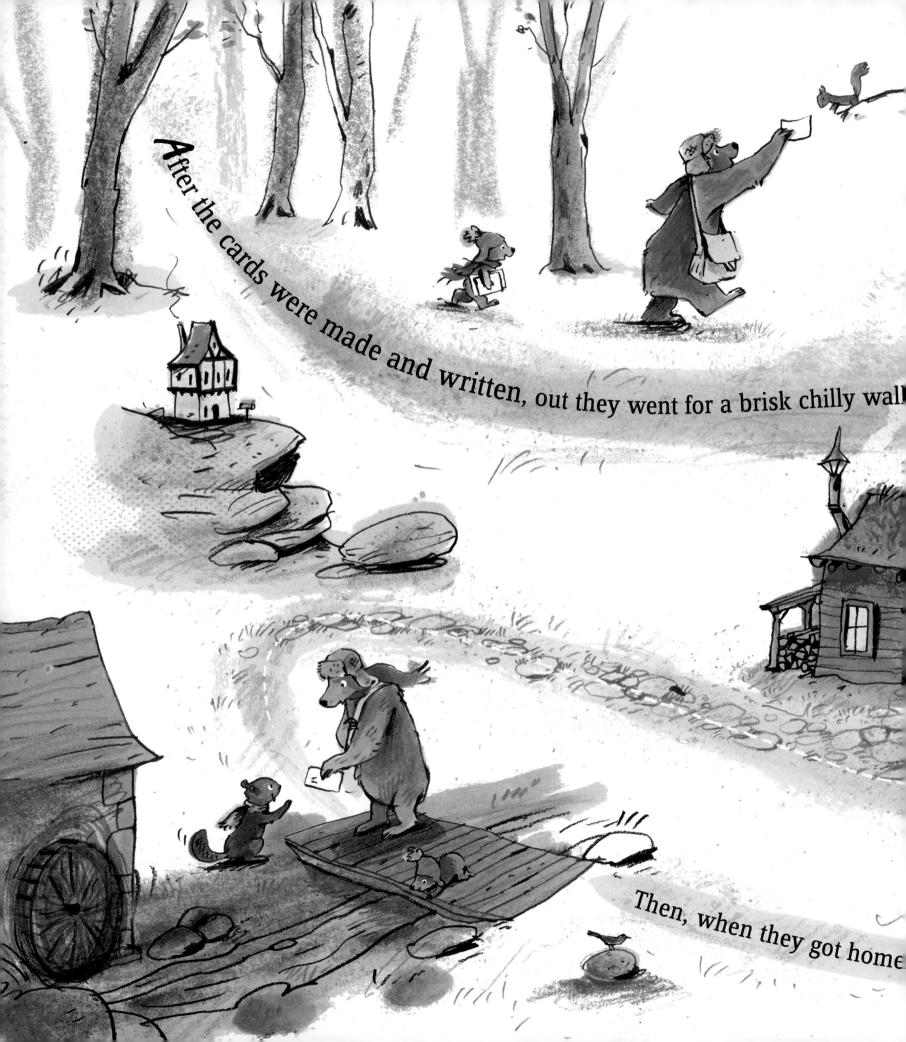

After the cards were made and written, out they went for a brisk chilly walk

Then, when they got home

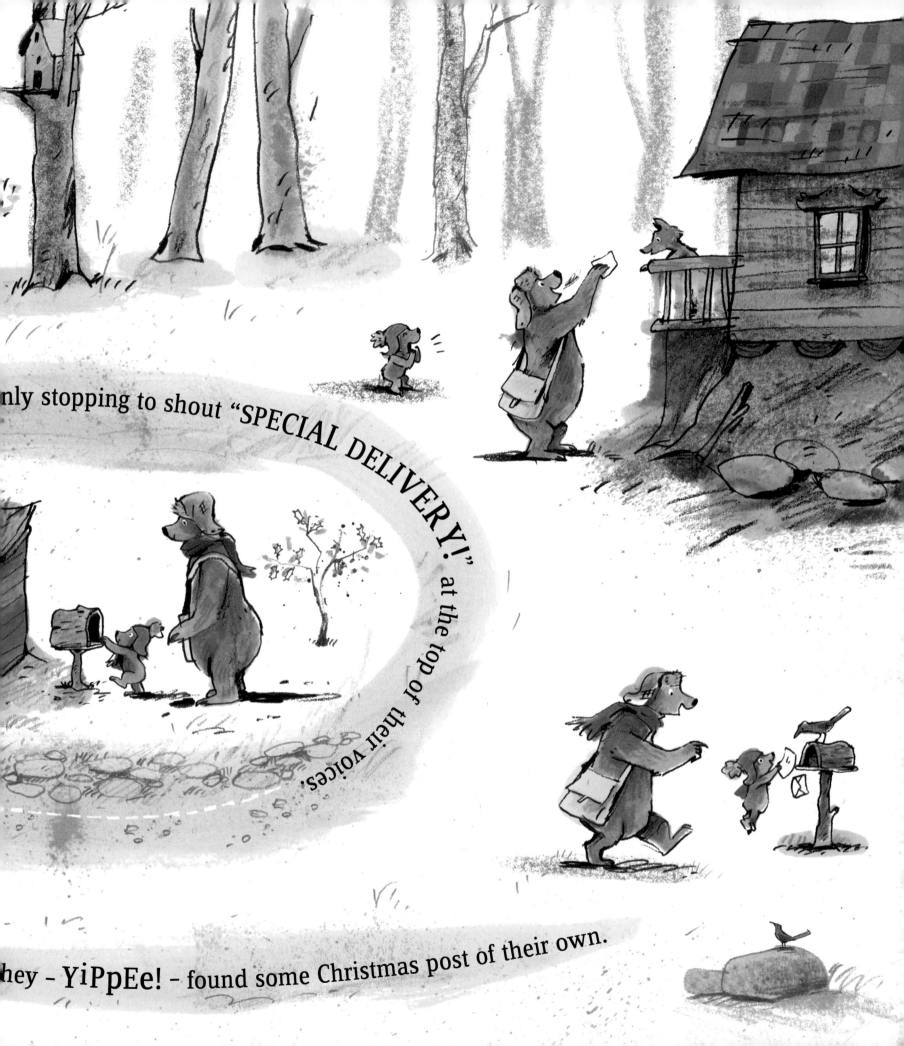

nly stopping to shout "SPECIAL DELIVERY!" at the top of their voices.

...hey - YiPpEe! - found some Christmas post of their own.

And by the time Little Pip was tucked in bed
not only had Daddy Grizzle displayed the cards . . .

but he had also explained
something that still
needed explaining . . .

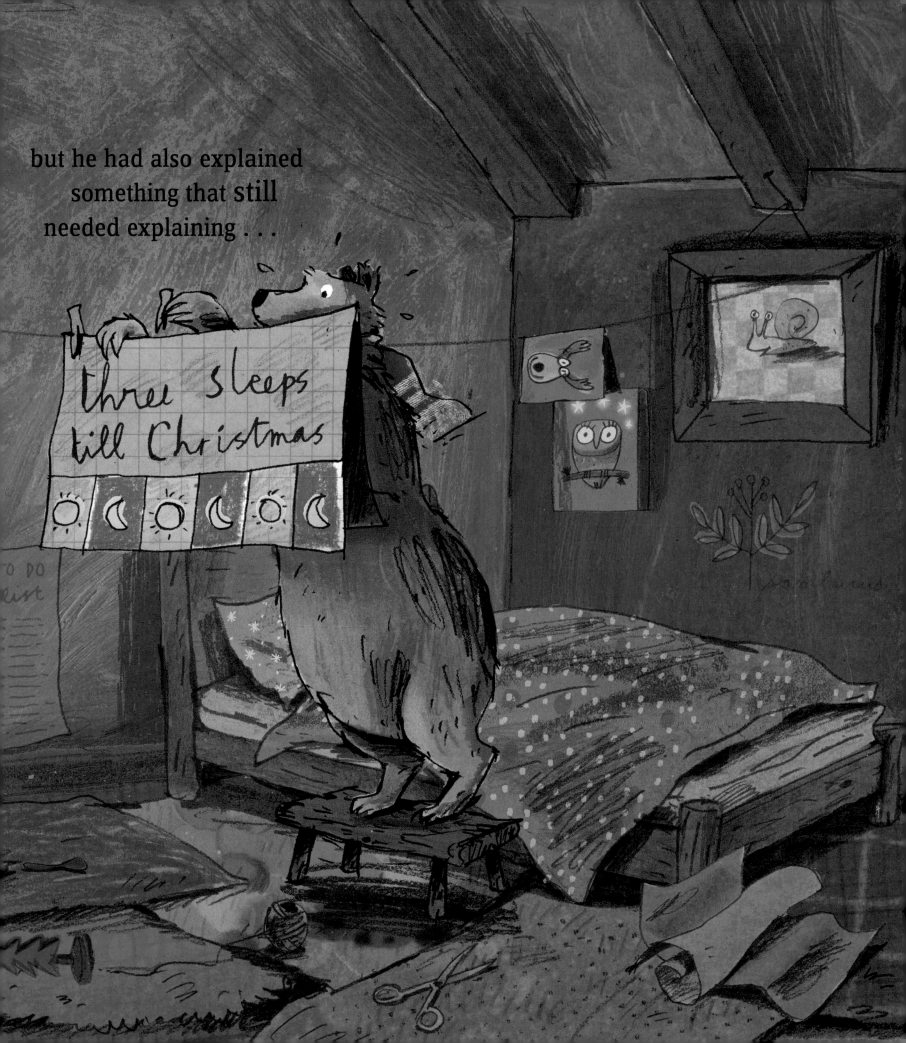

three sleeps
till Christmas

The next morning, Little Pip was just as confused as ever.

"PSSST!" said Little Pip. "WAKE UP!
I think it's Christmas Day!"

Daddy Grizzle rubbed his sleepy eyes.
"No," he yawned. "No, no, no,
not now! Not yet! First we
have some presents to wrap!"

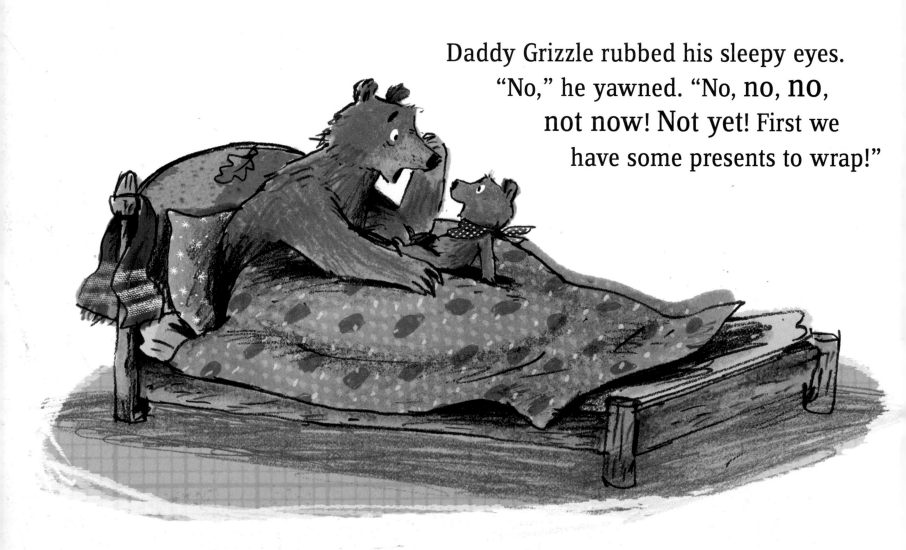

So they both sat themselves down, and (without looking over
their shoulders once) wrapped two 'No Peeking' presents
to be opened first thing on Christmas morning.

That night, after they had placed their presents under the tree, Little Pip watched the Christmas lights shimmer, **SHINE** and twinkle before climbing into bed.

TO PIP
Love from
Daddy GRIZZLE
xxx xxxxx

TO DADDY
GRIZZLE
Love from
PIP xxx

Later that night, Little Pip asked, "**HOW MANY SLEEPS** till **Christmas** now, Daddy?"

"Well . . ." said Daddy Grizzle with a thoughtful look, "we found a tree and handed out our cards . . .

We wrapped our presents and EVEN made two new friends . . .

Now, there's nothing else to do.
 So it's only one sleep till Christmas,
only **ONE** sleep to go."

"One!" smiled Little Pip. "Just ONE!"

And EVEN Daddy Grizzle felt
a shiver of excitement.

The next morning, EARLIER THAN EVER, a certain someone woke and realized

a very special day was FINALLY here . . .

"PsssST!"

And when Little Pip opened his tired eyes
there stood Daddy Grizzle, wide awake and beaming.
 "WAKE UP, WAKE UP, Little Pip!" cried Daddy Grizzle.
"It's YOU-KNOW-WHAT!"

Little Pip gasped and Daddy Grizzle let out a HUGE cheer
that rattled the windows and woke the whole wood . . .

"HuRRay! HuRRay! It's REALLY Christmas

Day!"

For Nel and Al (her Daddy Grizzle) - M. S.

For Leonie with love - S. B.

PUFFIN BOOKS
Published by the Penguin Group: London, New York,
Australia, Canada, India, Ireland, New Zealand and South Africa
Penguin Books Ltd, Registered Offices: 80 Strand, London WC2R 0RL, England
puffinbooks.com
First published 2013
001
Text copyright © Mark Sperring, 2013
Illustrations copyright © Sébastien Braun, 2013
Made and printed in China
ISBN: 978-0-718-19658-5